GALLUP

GALLUP

ROSWELL ANGIER AND SUSAN HAWLEY
AFTERWORD BY RAMONA EMERSON

THE MIT PRESS
CAMBRIDGE, MASSACHUSETTS
LONDON, ENGLAND

INTRODUCTION

The photographs and paintings that we made in Gallup are now history. They reverberate with old stories. Certainly the images are loaded with memories. The history portrayed in them is personal; it is about our effort, as artists, to comprehend what we were looking at, both in real time and subsequently, when we took up the project again in 2021 and decided to create a book. It is necessarily also a political story, because it involves the difficult inter-actions of several different communities in our country.

This book is about the everyday rhythms of a place burdened by mythic images of the American West. Gallup can appear to be a very ordinary place, where people do their laundry, hang out over weak coffee, calmly converse and shake hands on a downtown street corner. But underneath that layer, there are stories about events and entanglements that have explosive emotional power. These stories led to images with a surreal logic behind them. Hunting knives and Cherokee rose rocks floated in the space before the storefronts on Route 66.

I.

My interest in Native American culture was initially supported by a gift from my father when I was eighteen—a collection of Plains Indian objects, moccasins, a belt, a knife sheath, an embroidered vest and small toys, which an uncle of his, a rancher in Wyoming, had given to him years before. Now they were mine.

I had always had a somewhat eerie sense of belonging to two different sets of people—American and Canadian, although you might not think that the culture in Toronto, where my mother came from, was that different from New England. It was.

When Roswell and I started driving west we first headed south, and then in a long curve through Arkansas, Oklahoma, and the Texas Panhandle into New Mexico. Our first stop there was Tucumcari, where we were able to announce to ourselves, "We are here," before we moved on to Gallup and looked for a place to stay. This book is our look back at that very important nodal point in our lives.

In the years that followed, I volunteered at the Peabody Museum at Harvard, illustrating a thesis on Southwestern pottery, and through the Peabody I met someone who knew a man, Cecil Addison, a member of the Mohawk and Cherokee tribes, who was giving a Narragansett language class, open to any interested person, at the Narragansett Longhouse in Kingston, Rhode Island. He used Roger Williams's book *A Key to Languages in America*, published in 1643. It was a wonderful class. He was such a warm, delightful teacher.

Driving to Rhode Island, we always encountered a place on the interstate where the radio signal would begin to break up and we would hear fragments of voices from French-speaking Canada interrupting the local broadcast. It felt so appropriate to hear a strange kind of back and forth between English, or should I say American, and Québecois French—like a positive mirage through which we were literally traveling.

My own journey to Gallup was part of a constellation of road trips, both before and after the fact of being there. I am not certain of the chronology, but I remember a long taxi ride, in the early '90s, through rural Georgia. I was looking for the home of the Cherokee Chief James Vann. I was doing research for a series of paintings about the Cherokee Syllabary; in the syllabary language, I found a prayer for travelers.

Then there was the hitchhiker whom I saw outside of Spiro, Oklahoma. Spiro was interesting because there was a large Indian mound there that had been excavated during the Depression by unemployed miners who were subsequently given work by the Civilian Conservation Corps. A book about the ceremonial culture in that area spoke to the extensive trade routes all over the central and southern part of the continent. This particular hitchhiker was standing near a sign saying "Warning: hitchhikers may be escaped convicts." We saw

many people who had walked for very long distances in the Southwest. The hitchhiker became an important figure, expressing both hopefulness and resignation, emotions I experienced many times in Gallup and often saw in others.

Susan Hawley, June 2022

II.

Before going there, I knew nothing of Gallup, and nothing about the Southwest in general. I was familiar with a Robert Frank photograph of a somber Navajo cowboy, taken surreptitiously by Frank in a Gallup bar in the 1950s. The picture stayed with me. The place, which I drove through in 1962, did not. It seemed vacant and empty of appeal.

I decided to go there because of a conversation I had with my father in 1966. His mother had recently died and the whole family had gathered in Tucson, at my uncle's house outside town. I had come from California, where I was going to graduate school. I hadn't seen my father for three years.

It was the 4th of July. There was desultory conversation about the holiday. My father, who had a penchant for making abrupt sotto voce pronouncements, offered an opinion about our treatment of indigenous people. His tone wasn't argumentative. His words just hung there, an unsolicited opinion on the loose, and drifted away. He died later that day as a result of a fireworks accident, so we never got a chance to pursue the conversation.

More than a decade later, on our way west we stopped at Tucumcari. As soon as we had settled into a motel, I set off in the car to have a look at the local terrain. It was getting dark. Something caught my eye. Behind the tightly locked gate to a chain link fence, in the parking lot of an auto body shop, reposing in a pool of light, was an unhooked Airstream trailer. It was glowing. I got out my tripod. As I was setting the camera up for this shot of classic Americana, a police cruiser pulled up beside me. I had a hard time explaining to the officer exactly what I was doing, so he directed me to follow him to headquarters, where he could ask more questions. Once there, I finally managed to convince him that I was not engaged in industrial espionage.

The encounter in Tucumcari was hardly a surprise to me. Like many other photographers, I have been questioned by all sorts of people about my motives for photographing in places where I did not appear to belong. But this incident threw my notion of what I was doing out here, in this place, into a strange sort of relief. The Airstream trailer tableau was a simple matter of old-fashioned Cliché Picturesque, a reasonably familiar trope. So what, then, was coming up, down the road, at our eventual destination?

At first glance, Gallup seemed to us like the edge of the world, an epitome of otherness, rife with an upside-down exotic appeal. Of course it was not that at all, as we gradually realized. It was layered. It was an in-between place, where people from different cultures came into contact and often collided with each other, often struggling to maintain their identities and not be overwhelmed by other people's assumptions about who they were. Sometimes it seems as if the world has become increasingly consumed by this battle. It's a very old story.

Gallup is a city full of sad stories with predictable outcomes. But some of the stories about people we came to know had unexpected endings. So it was with Johnny Secatero, whose obituary we discovered online last year, 40-some years after we last saw him. Johnny was an artist who painted finely detailed images of kachina dancers. He was a Vietnam veteran, and had been a Golden Gloves boxer in his youth. He was also an alcoholic. We met him and his wife Wanda on the street, on Route 66. He had come to Gallup to collect some money due him, from some traders who had sold some of his paintings at the annual Inter-Tribal Ceremonial. We drove Johnny and Wanda home to Lukachukai, about 100 miles northwest of Gallup, and spent the night there in his family hogan. You'll read that story later in this book.

Johnny changed his life during the years that followed our encounter with him. His obituary informed us that he died on August 25, 2010. By that time, he had graduated from Diné College, completed a master's degree in education, and taught Navajo language and culture at the Lukachukai Community School. He had also served two terms in the local tribal governing body, as the chapter vice-president.

The first person I encountered in Gallup was Roger Pablo. He became my guide, and later a friend. I walked into his office in a counseling center one morning, where he worked as a substance abuse counselor. It was the day after John Wayne died. I told Roger that I was working on a book project (which was at that point only an aspiration) and asked for his assistance in locating recovering alcoholics who would be willing to be interviewed. To my surprise, he was immediately receptive, and we ended up talking for a few hours. Susan and I spent a lot of time together with him and his wife, Eleanor, while we were working on this project.

Although I talked to many people in Gallup and on the reservation, I never got around to conducting really formal interviews. Roger referred me to a few people, whom I visited on the reservation, but I mostly relied on chance encounters on the street. The most interesting thing about Roger's referrals was the maps he would draw, with driving directions to various destinations on the reservation. Road signs were scarce out there, and street addresses nonexistent, so he would draw elaborate patterns of lines and curvaceous squiggles, arabesques really, on scrap paper. There were no written words. His maps were purely visual objects. He would talk me through them as he made his markings, and I would remember later what he said.

Roger had an occasionally solemn manner, which was usually a signal that he was on the verge of trying to make a joke related to his tribal identity. Once while we were having lunch at the Best Western Motel restaurant buffet, he said to me, very slowly, "You know, I bet I'm the only Navajo in Gallup who comes here for the salad bar."

His solemnity also took the form of an especially assertive kind of silence. This occurred once during a long drive to a gathering of his clan, the Water Clan, on the eastern edge of the reservation. On the drive out, I was behind the wheel, and we collided with a crow. The bird flew into the windshield as we drove through Coyote Canyon. I kept on driving. Roger said nothing, but I noticed out of the side of my eye that he had a strange look on his face that I had never noticed before. I couldn't place it, and it bothered me. I asked him if there was anything he thought we should do about the bird, and he didn't say anything. He just shook his head. So I drove on.

On the way back to Gallup, we passed through Coyote Canyon again, and the car had a blowout. I got out of the car to have a look, and I saw that the right front tire was flat. I looked around to see if we'd run over anything. We hadn't, but I did see something by the side of the road.

A dead crow.

When I got back to the car, Roger didn't say anything, and he gave me that disquieting, solemn look again. We changed the tire and continued the drive mostly in silence.

Later, when I asked him if I had done anything to upset him, he told me he didn't know what I was talking about.

Roswell Angier, June 2022

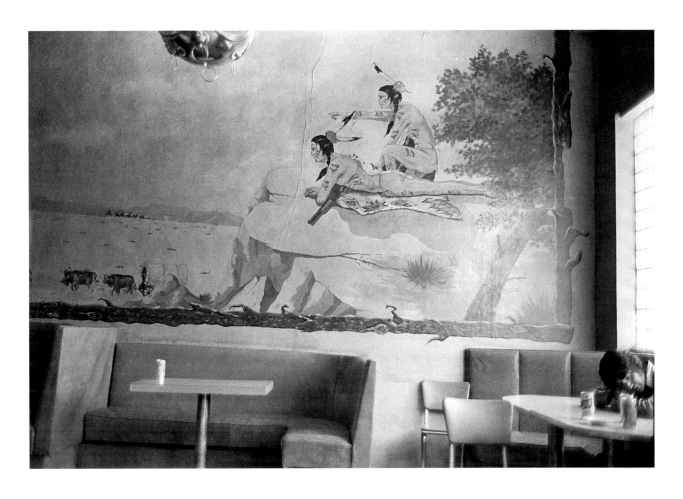

American Bar, Gallup, 1979

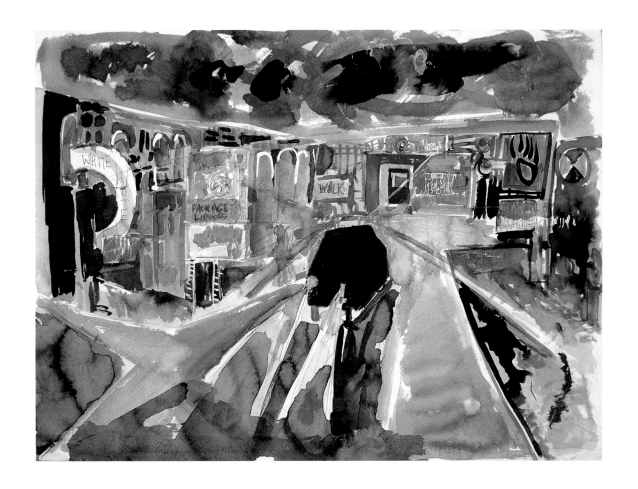

Night Patrol, Gallup, 1979

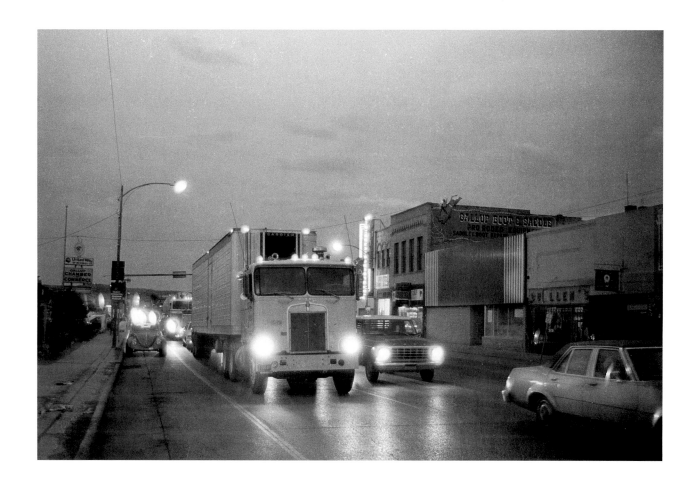

Route 66, Gallup, 1979

In the Navajo Creation Story, in what is called the First World, there are only the Insect People, who spend their time ceaselessly milling around, without goal or pattern. It is very much like Brownian motion, a state of being that is defined by endless random activity. This state of affairs lasts until a leader, named Pot Carrier Beetle, appears. He discovers a hole in the ceiling of the First World, and leads the People up through this hole, into the Second World, where they begin to acquire consciousness and purpose. Navajos refer to this event as the Emergence.

RA, journal entry, June 11, 1980

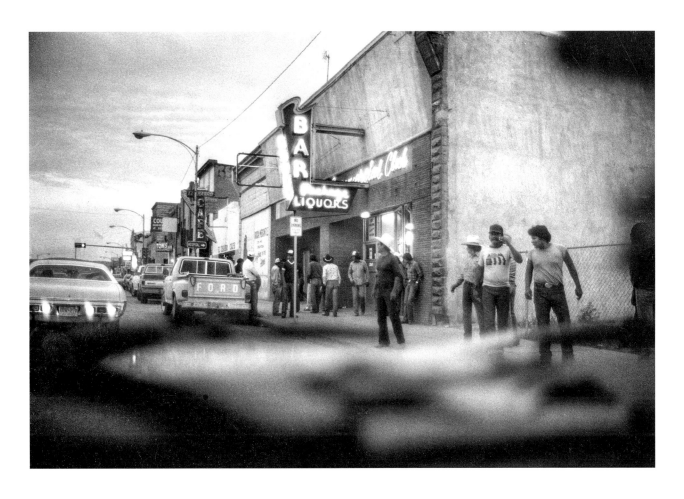

Downtown Gallup, 1979

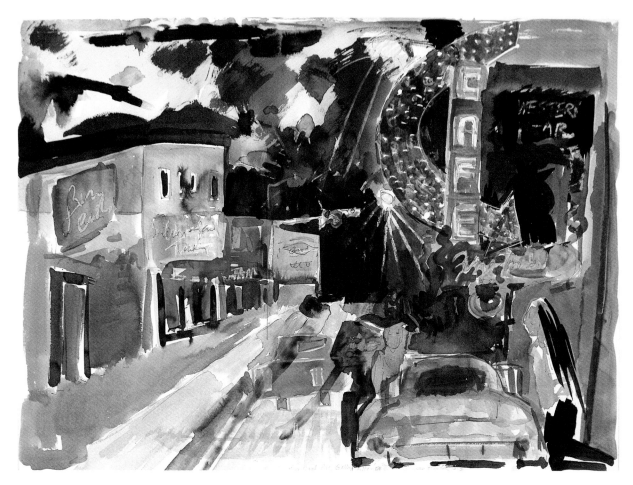

Downtown Gallup at Night, 1979

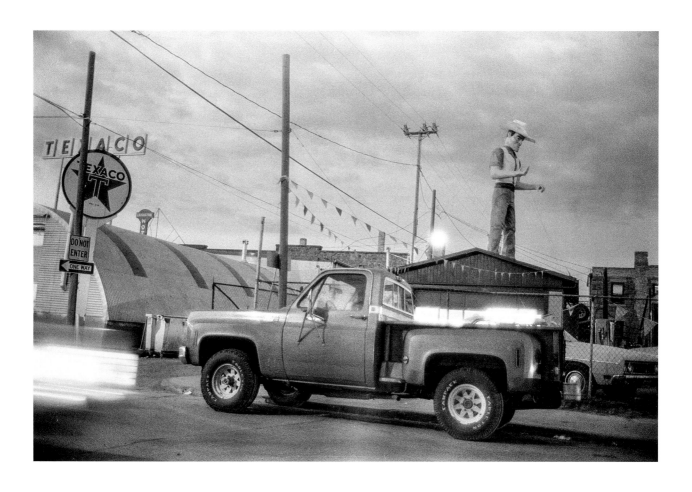

Gallup, 1979

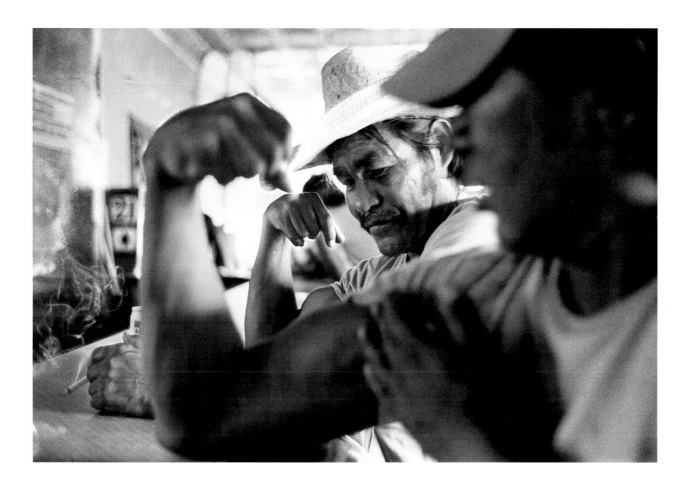

Indian Head Bar, Holbrook, Arizona, 1980

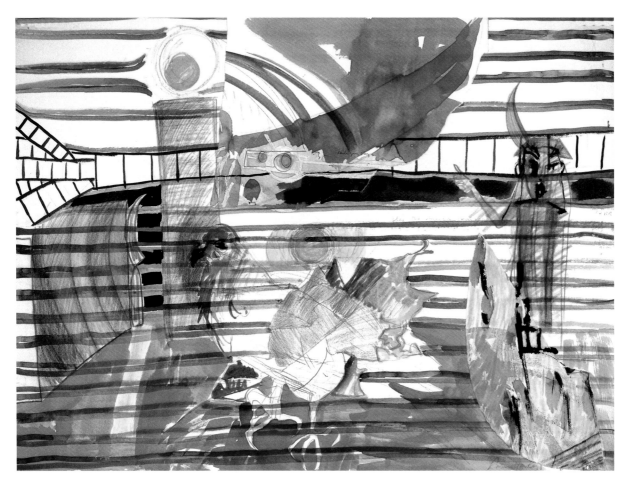

Hitchhiker, Chicken, and Railroad Tracks, Outside Gallup, 1980

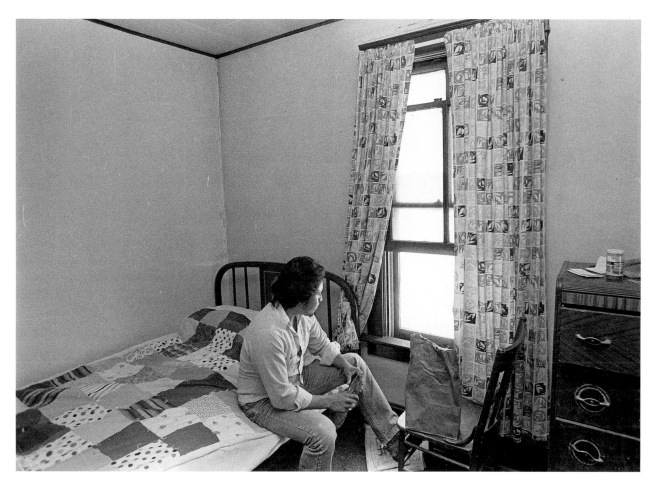

Hotel Delmar, Gallup, 1979

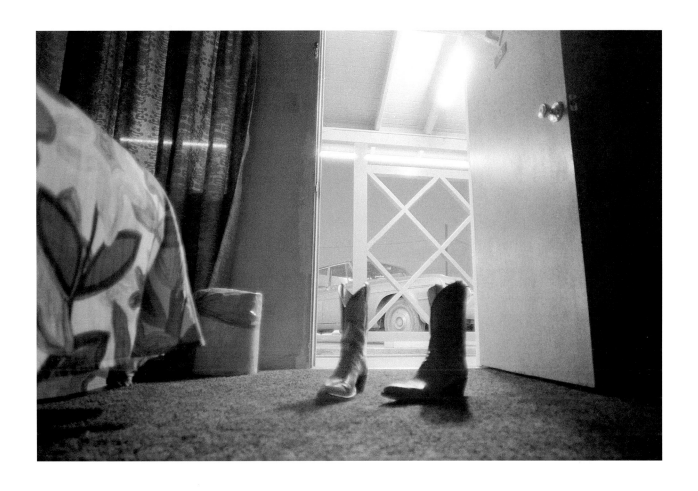

New Year's Eve, Golden Desert Motel, Gallup, 1980

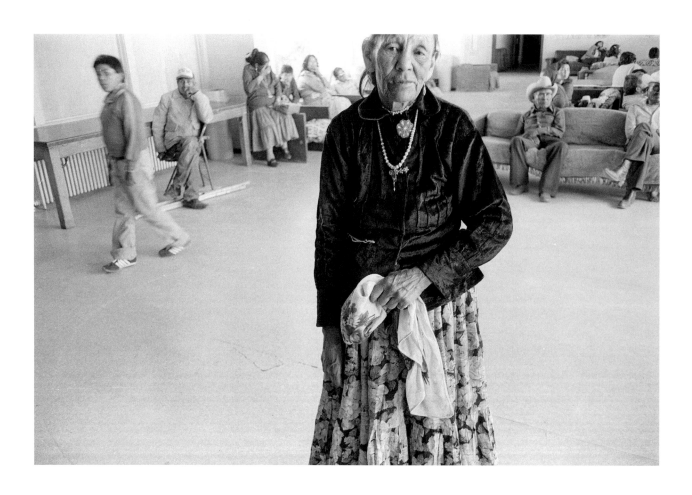

Gallup Indian Center, 1981

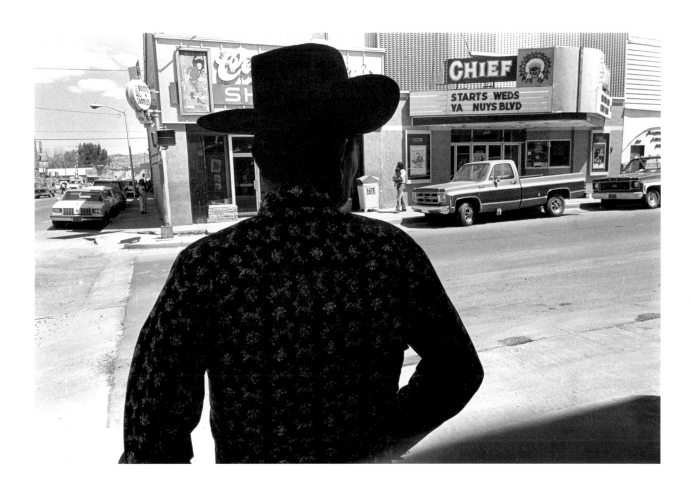

Coal Avenue, Gallup, 1979

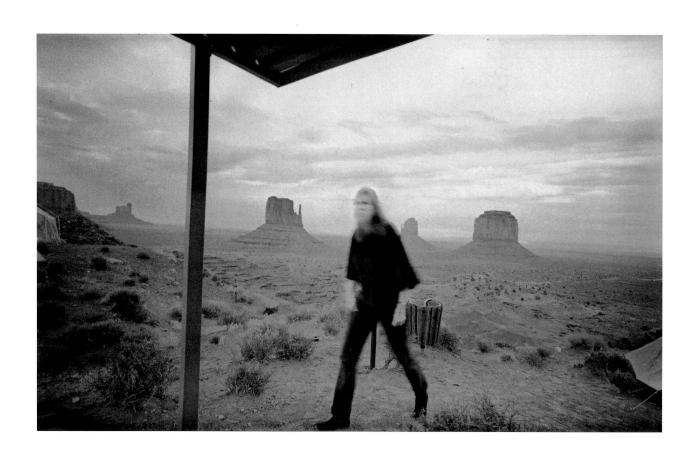

Susan, Monument Valley, Navajo Nation, 1980

Golden Desert Motel, Route 66, R Smoking, 1979

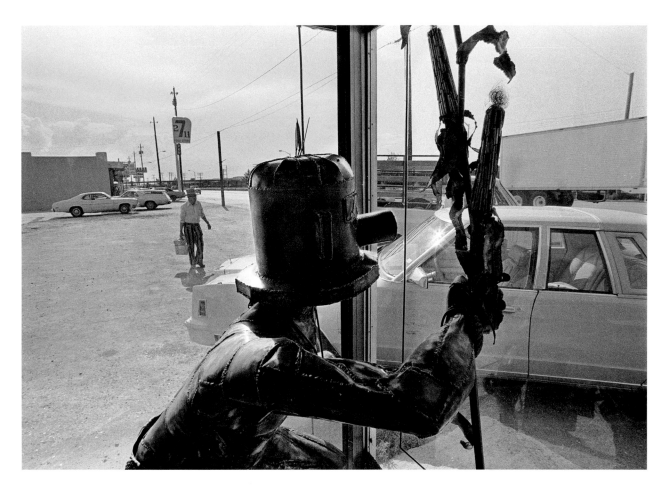

Window Display, Gallup, 1980

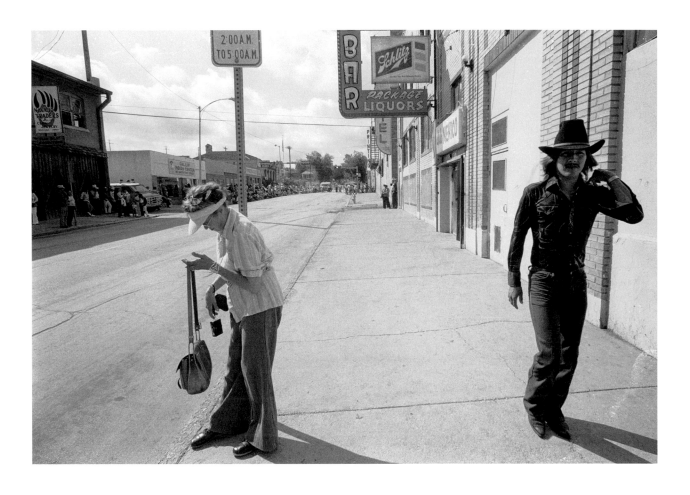

Outside Club Mexico, Gallup, 1979

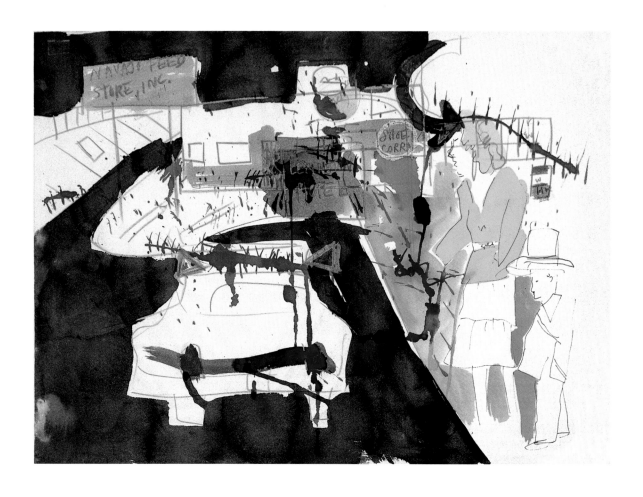

Outside Feed Store, Gallup, 1980

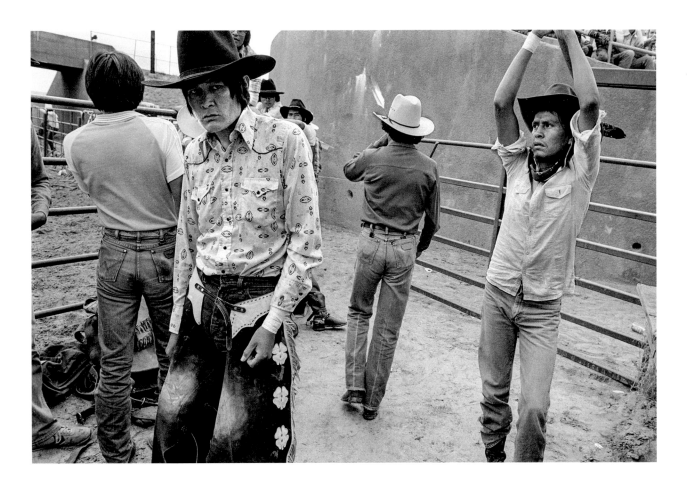

Lions Club Rodeo, Gallup, 1980

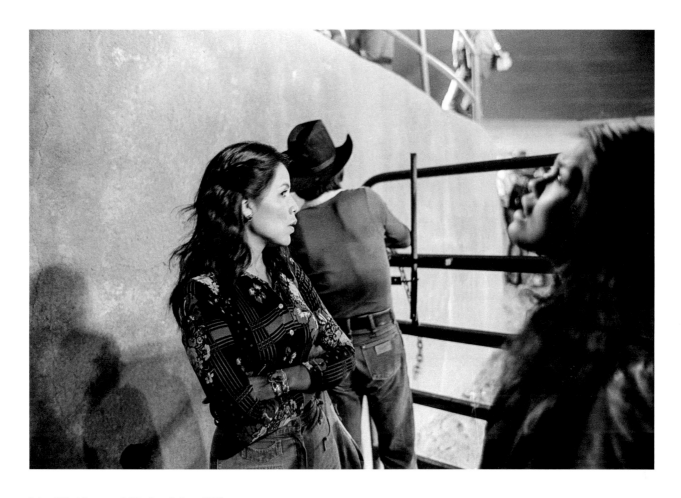

Inter-Tribal Ceremonial Rodeo, Gallup, 1979

Shortly before my father died, he gave me an old leather suitcase full of Plains Indian artifacts. They had come to him from an uncle, who had been a rancher in Wyoming. I mourned my father's death by painting the contents of the suitcase, until the objects asserted themselves as things with their own history, and my father's spirit left them. After that, I wanted to go west. In New England, where I grew up, I was conscious of the many places that had Indian names, but the native cultures had long since been assimilated or destroyed. I wanted to make contact with the living. Gallup, at one end of the Navajo Nation, was where I ended up, along with my husband Roswell. Some people have called it the last frontier town in America. Many Navajo street people speak fondly of the fact that *The Hallelujah Trail* was filmed there. The Chamber of Commerce has erected a billboard at the eastern edge of town with a picture of a Navajo woman and the words "Welcome to the Indian Capital of the World." The city started as a stagecoach stop with a store and a saloon called The Blue Goose. You can still read the faded words "Kitchen's Opera House" on the facade of a downtown store. Some take that as an emblem of harmony, an indication of the city's claim to a folksy grace. On the other hand, according to a Navajo acquaintance, if it weren't for all the bars, fast food joints, Indian pawn shops and jewelry stores, there wouldn't be anything in Gallup but blowing tumbleweeds.

SH, journal entry, August 24, 1983

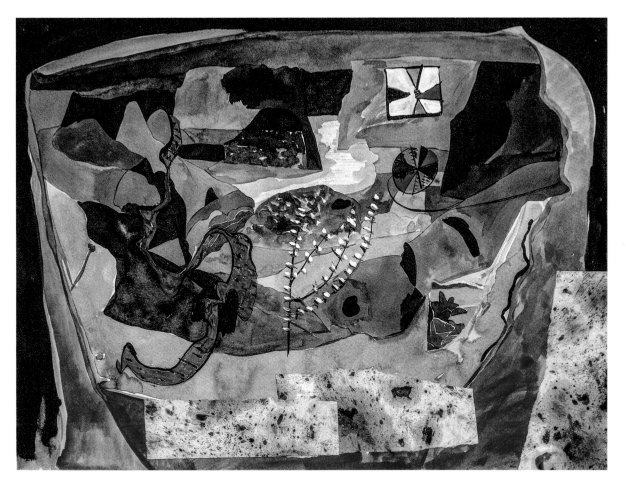

Cave, Canyon de Chelly, 1980

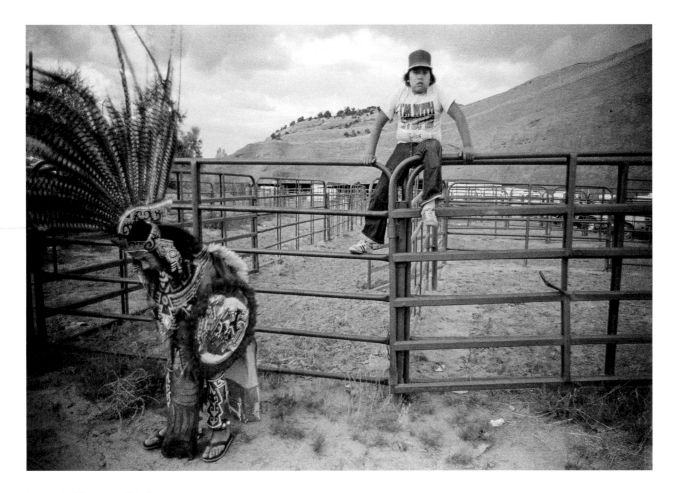

Inter-Tribal Ceremonial, Gallup, 1979

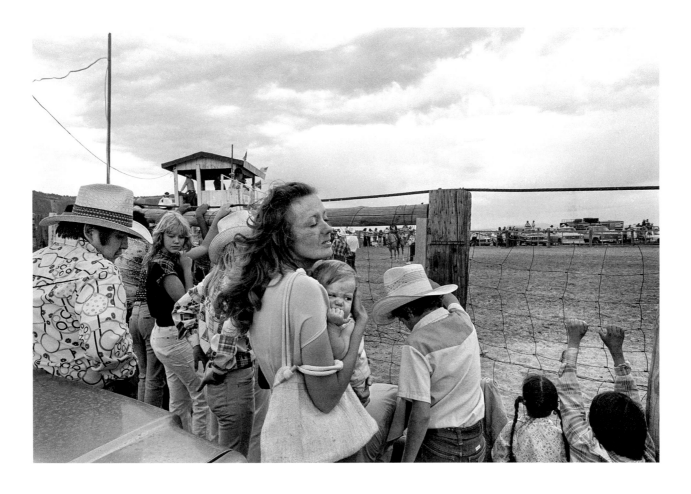

Paddy Martinez Memorial Rodeo, Thoreau, New Mexico, 1980

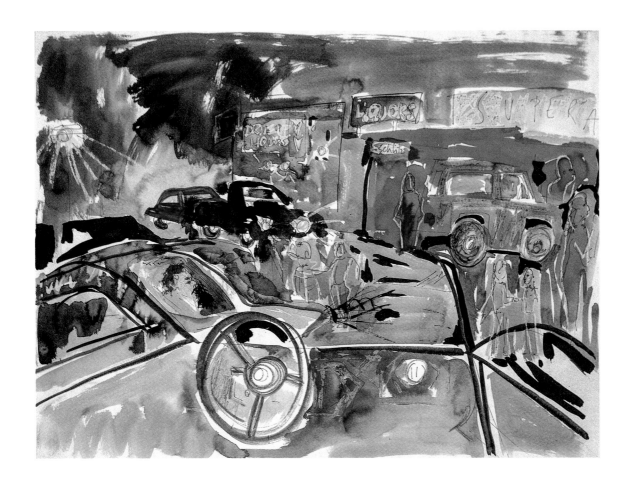

Drive-in Liquor Store, Route 66, 1980

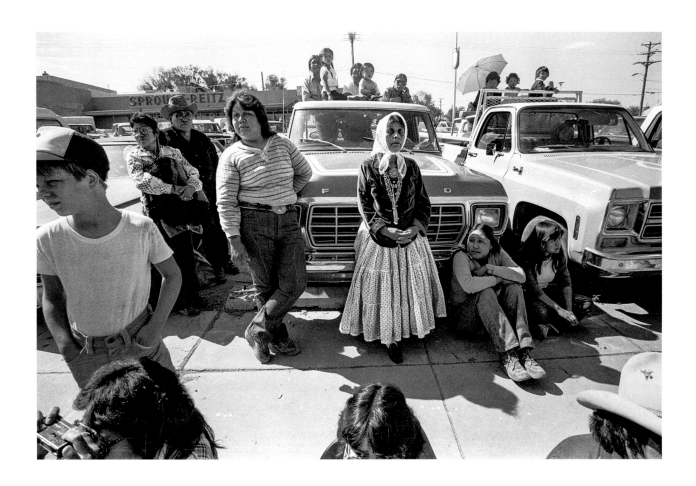

Parade, Gallup, 1981

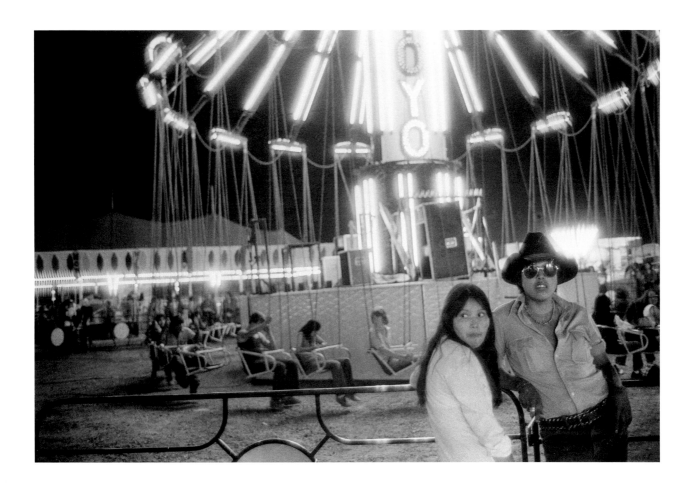

Carnival, Gallup, 1979

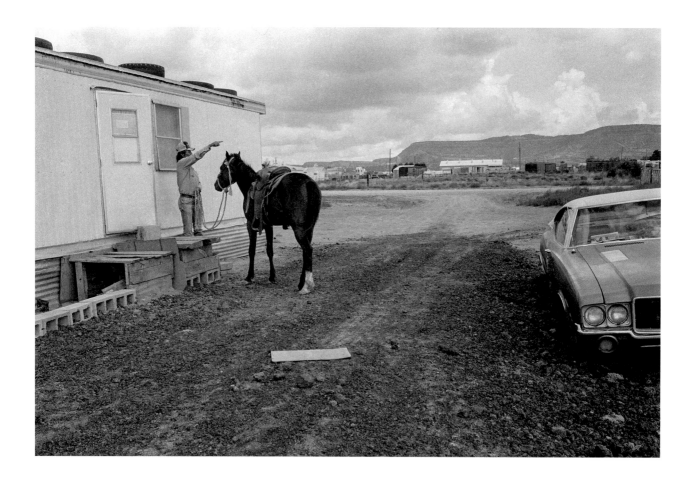

Bronco Martinez, Thoreau, New Mexico, 1981

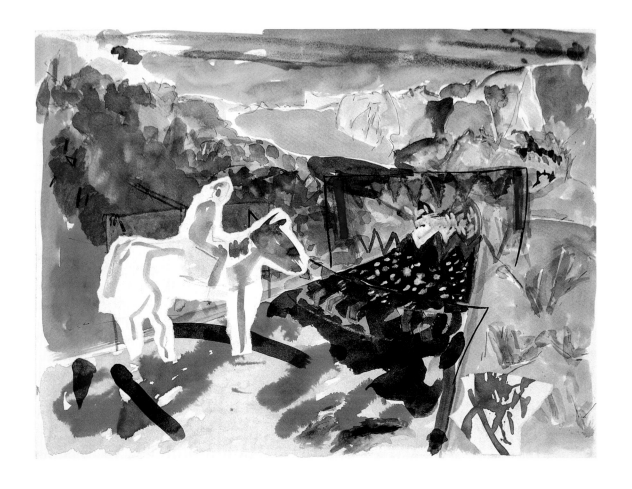

Road to Zuni, 1981

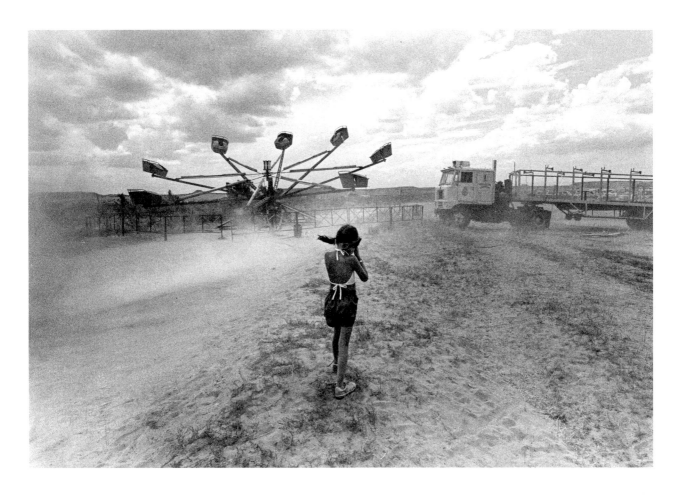

Pow-Wow, Navajo Nation, Lukachukai, Arizona, 1980

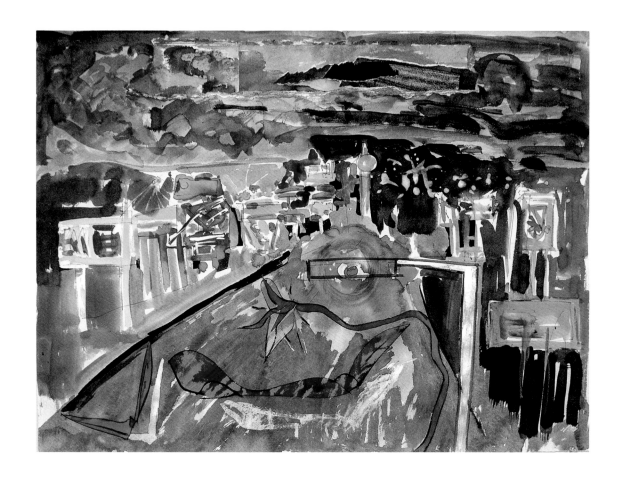

Coal Avenue, Gallup, 1979

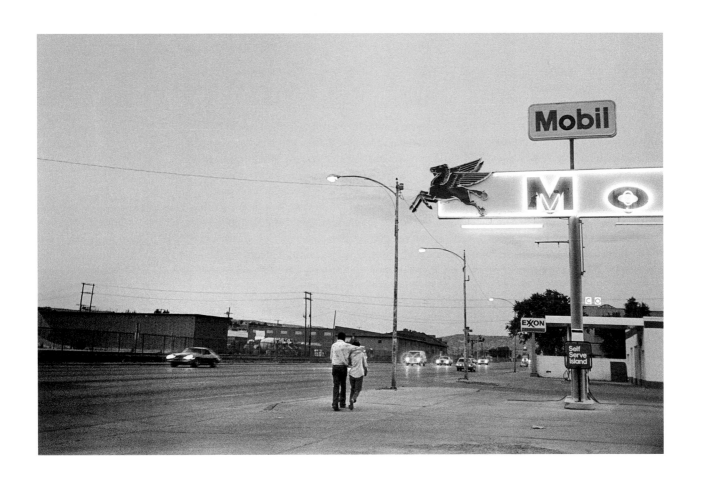

Route 66, Gallup, 1979

We arrived in Gallup the day after John Wayne died. The next morning, in the Liberty Café, I met an old man named Sam Roanhorse. He gave me an arrowhead. Over the next few weeks, I began to think Sam was everywhere. As I drove around town or walked along Route 66, hunting for images, his bony profile kept showing up at the edges of my vision. Sometimes it seemed that we were following each other. I would run into him in the unlikeliest places. Early one morning, walking my dog in the hills outside town, I came upon him in the scrub brush, sitting on a rock. He had a clean white towel draped around his shoulders. Mostly, though, Sam just walked. Up and down US 66, on his own or performing errands for one of the downtown traders. He was restless. Always on the move. When we talked, the conversation was always brief and always good-natured. It always began the same way. "Where're you going," I'd say. "Nowhere," he'd answer after a considered pause, wrinkles easing out of the corners of his eyes like wings.

RA, journal entry, June 23, 1980

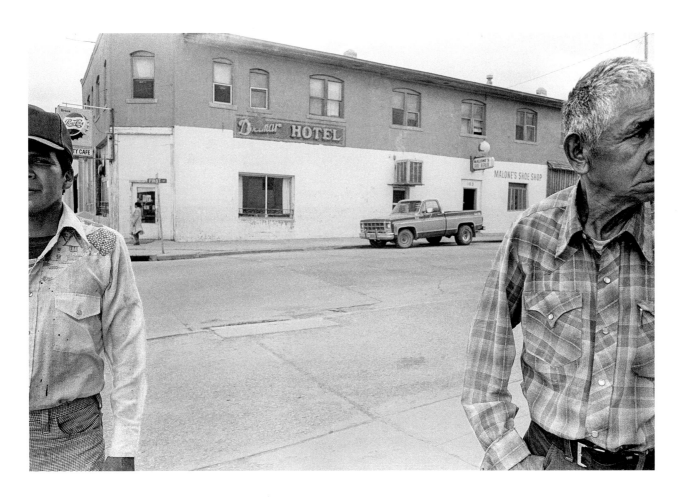

Emerson Shorty and Sam Roanhorse, Gallup, 1979

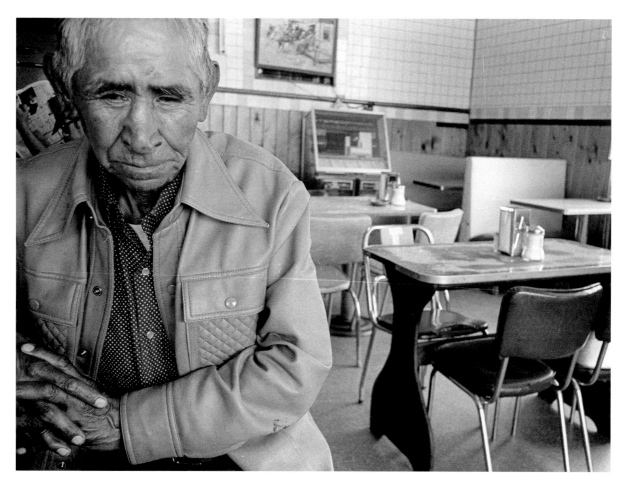

Sam Roanhorse, Gallup, 1979

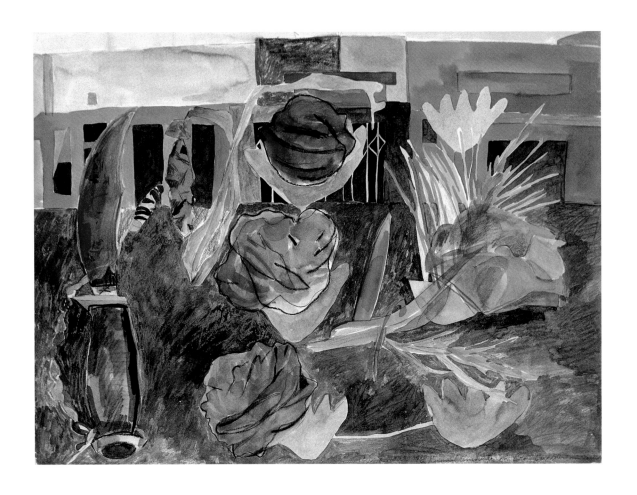

Storefronts, Route 66, Gallup, 1979

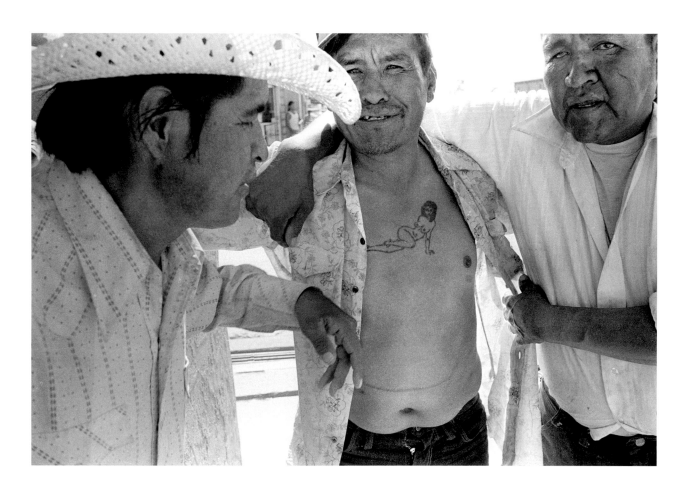

Roscoe Anderson and Friends, Gallup, 1979

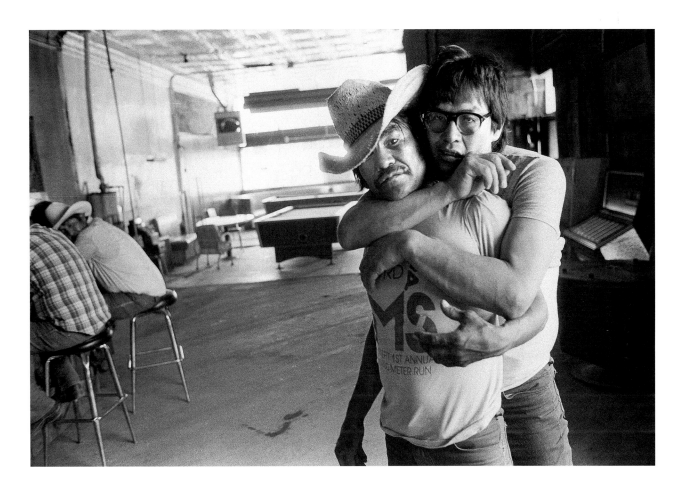

Indian Head Bar, Holbrook, Arizona, 1980

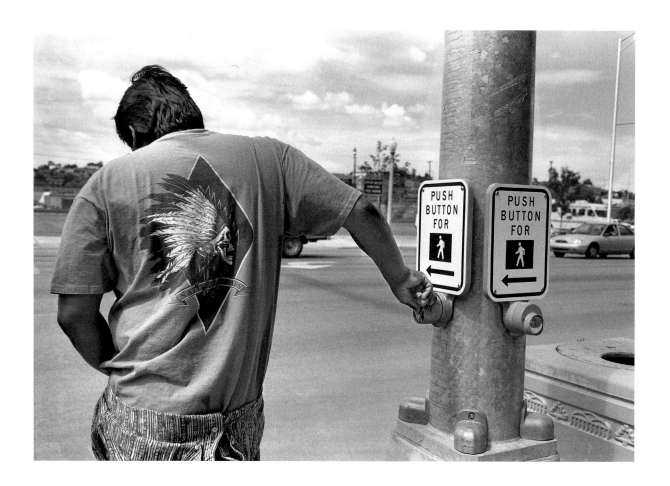

Tourist, Gallup, 1990

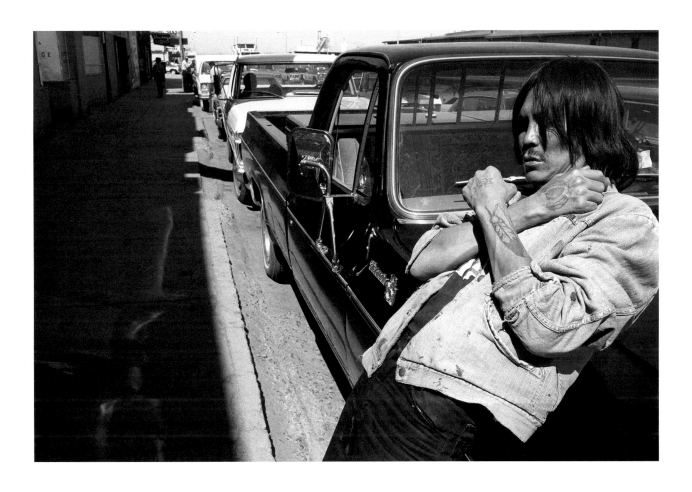

Irving Begay, Gallup, 1979

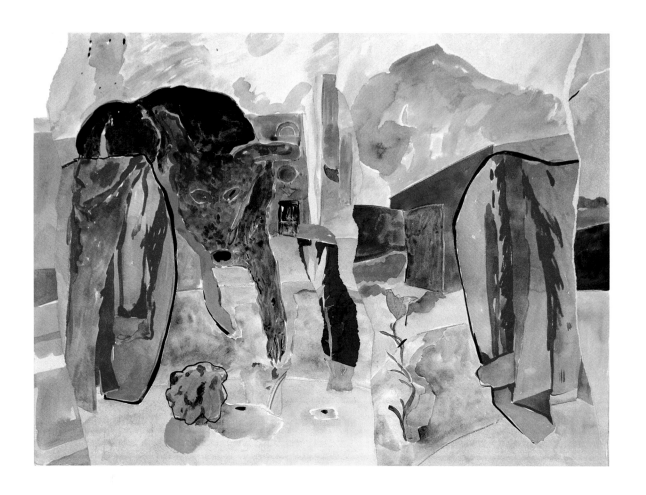

Red Jacket and Beckett, 1980

72

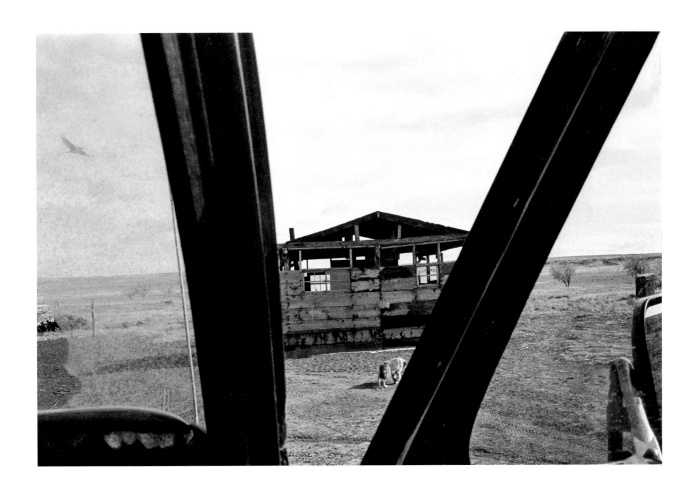

Eastern Agency, Navajo Nation, 1980

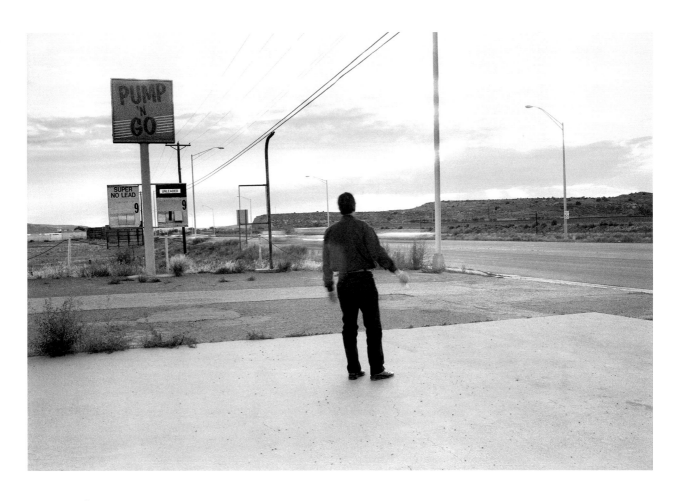

Route 66, Gallup, 1980

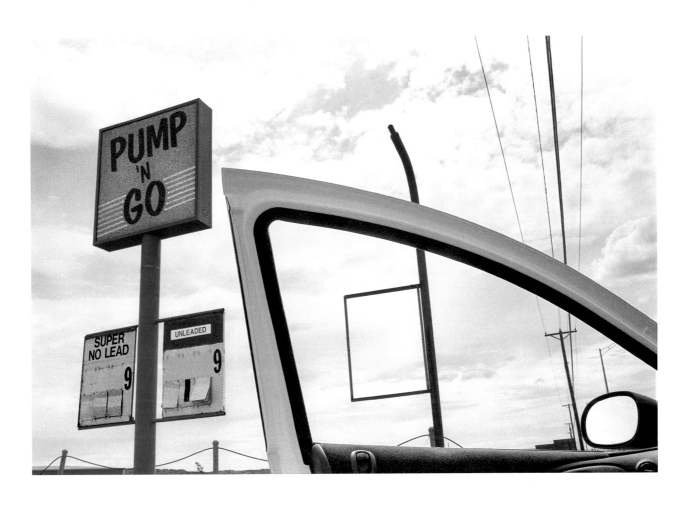

Big Bear Mall, North of Gallup, 1980

"Who goes there? hankering, gross, mystical, nude"

Walt Whitman, section 20, *Song of Myself*, 1855

I don't remember anymore. Was the man who looked like a crow the same as the hitchhiker
I saw just down the road from the sign saying:

WARNING! HITCHHIKERS MAY BE ESCAPED CONVICTS

SH, journal entry, July 16, 1980

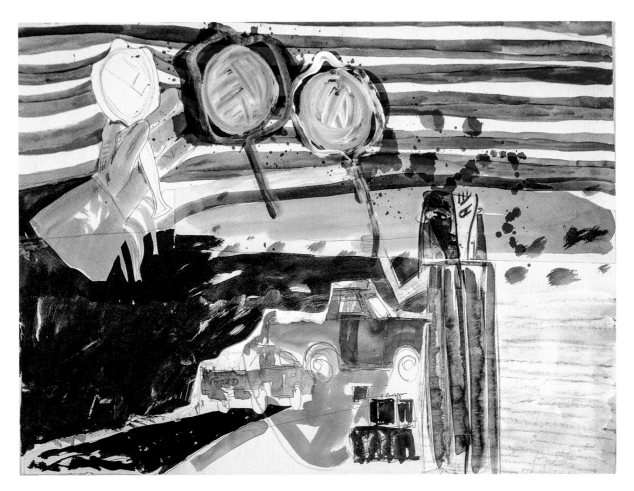

Hitchhiker, 1980

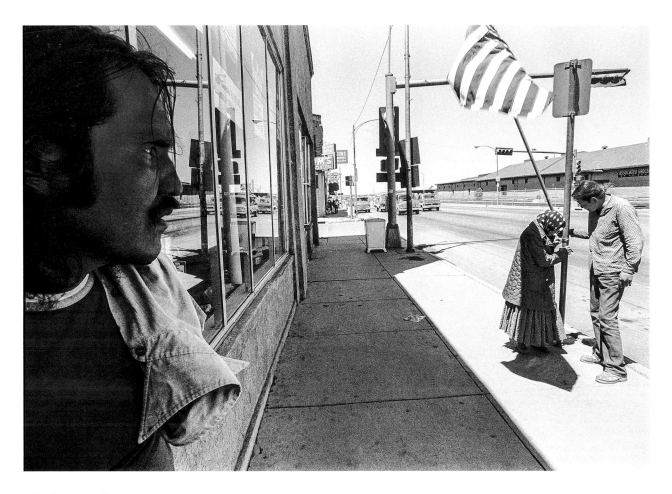

July 4th, 1980, Gallup

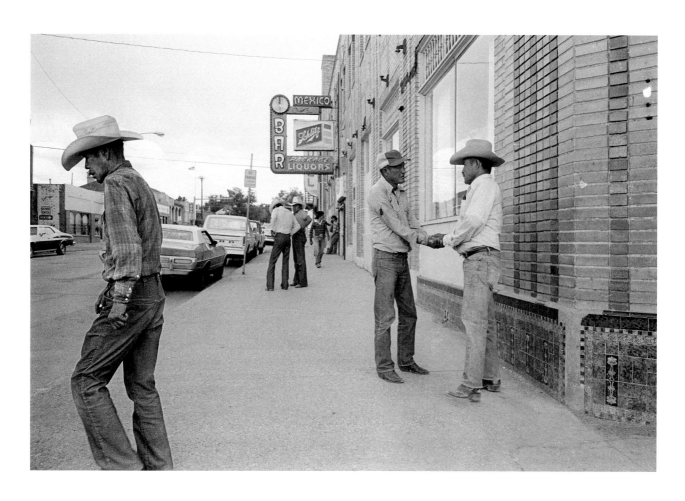

Down the Street from Club Mexico, Gallup, 1979

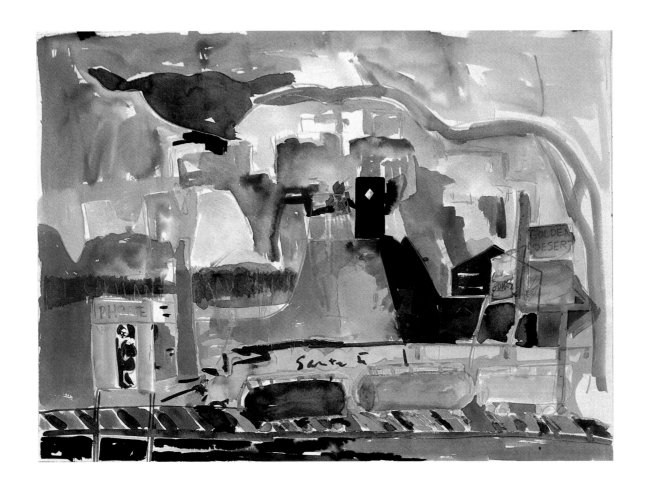

If the Santa Fe Ran Past White House Ruin, 1980

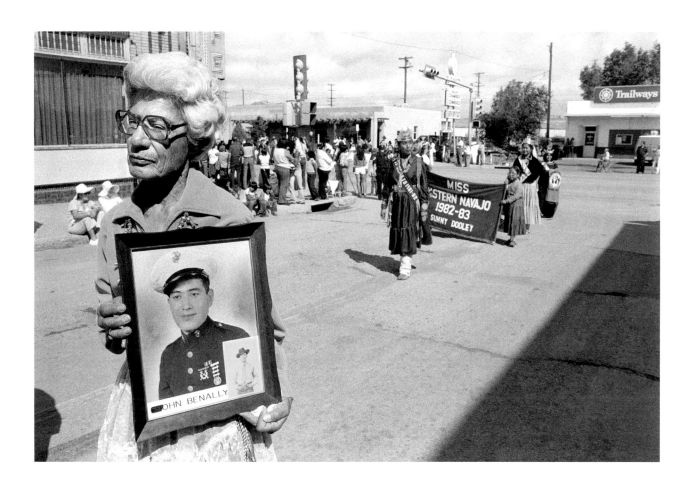

Navajo Code Talker's Widow, Parade, Gallup, 1980

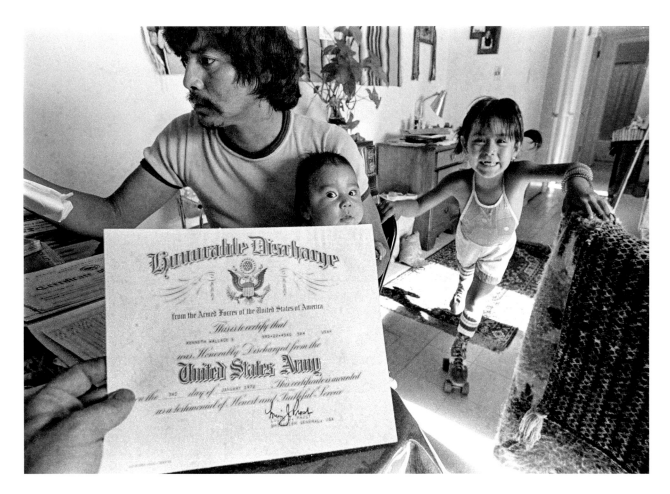

Wally and His Kids, Gallup, 1980

I'm sick of Gallup. Sick of drunks. Weary of this one-room bunker of an apartment where I process film in a dusty bathroom with a towel jammed under the door to keep the light out. I'm fatigued by my pictures, by the way the camera frame constantly finds tension between its edges or corners. Tired of seeing large out-of-focus faces looming toward me as I look through the viewfinder. I wish I could take a few simple pictures. For instance, a plain portrait of Roscoe Anderson, the sweet passive drunk I have come to regard sometimes as my double. We have the same initials. I once mistakenly signed his name to something, instead of my own. Roscoe, the man Roger Pablo said was a proud person before his wife was killed in front of his eyes, the man whose son was born on New Year's Day, the same day on which Roscoe himself was born, 28 years earlier. I tried to make that simple portrait, but Roscoe's face is always too close to bring into focus, or it is partly obscured by a plastic flower in a vase that separates us as we sit across from each other in the Greek's café, or I become transfixed by something he shows me one night in the drunk tank at the city jail. It's a VA Hospital appointment card that says he's been exposed to Agent Orange in Vietnam. I can't help focusing on those evil words, while Roscoe smiles helplessly and out of focus in the background.

RA, journal entry, August 22, 1980

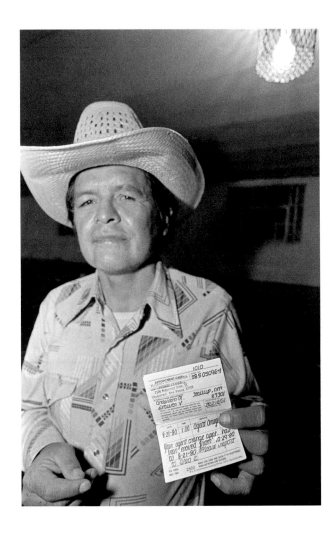

Roscoe Anderson and His Agent Orange Appointment Card,
Gallup City Jail, 1979

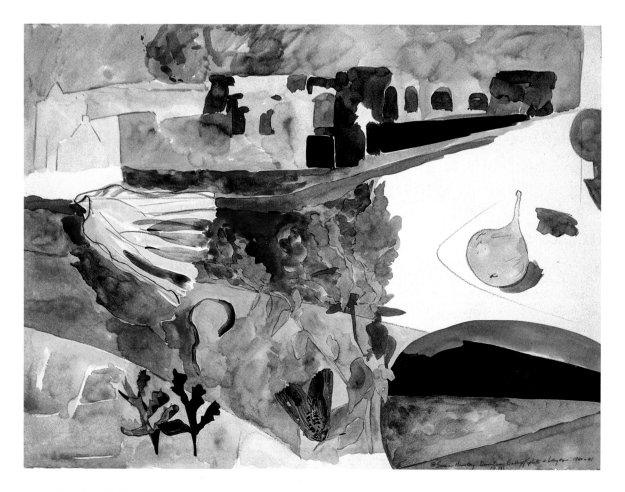

Corner, Downtown Gallup, 1979

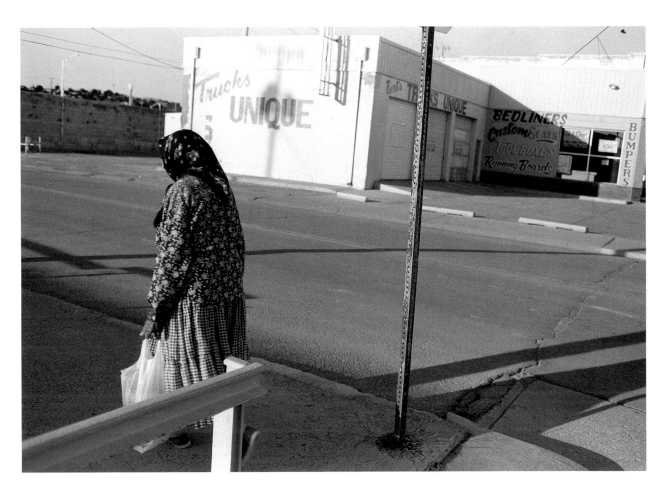

Gallup, 1980

Roscoe talks in a whisper. He was a radio operator in Vietnam. Now he talks about the Mexicans who broke his legs a few winters ago while he was passed out by the side of the road on the north side of town. He says they were trying to steal his boots.

He talks about last February, when his wife died. She was choked and then run over by six men in the parking lot of The Tropics Bar in Gamerco. He says he's been drunk ever since. He tells me about his cousin Larry, whose left arm was sheared off by the wheel of a flatbed freight car. He tells me about finding a young Navajo woman down by the Rio Puerco last winter, frozen to death with blood all over her face. "She was naked," he says, "except for a pair of red sneakers."

RA, journal entry, July 28, 1979

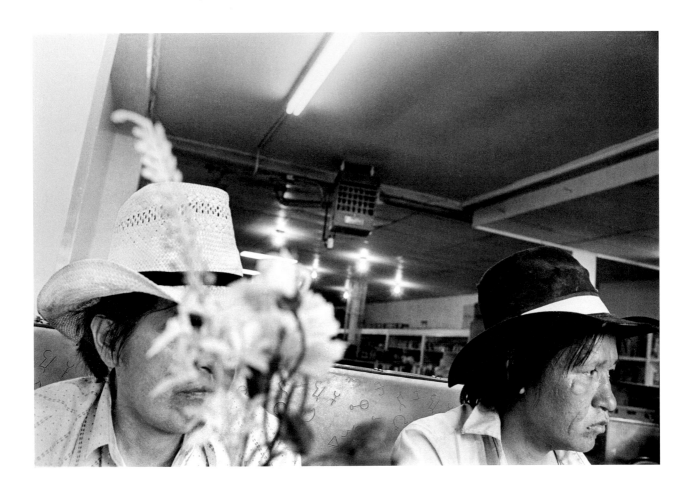

Roscoe Anderson and His Brother Ernest, New Inn Café, Gallup, 1979

APPARITION OF THE HIGHWAY WARNING:

Don't get lost
Don't try to fly as the crow.
We are not birds.
Think about the road,
the time it takes to find a path,
to know who it is
by the side of the road.

SH, journal entry, June 11, 1979

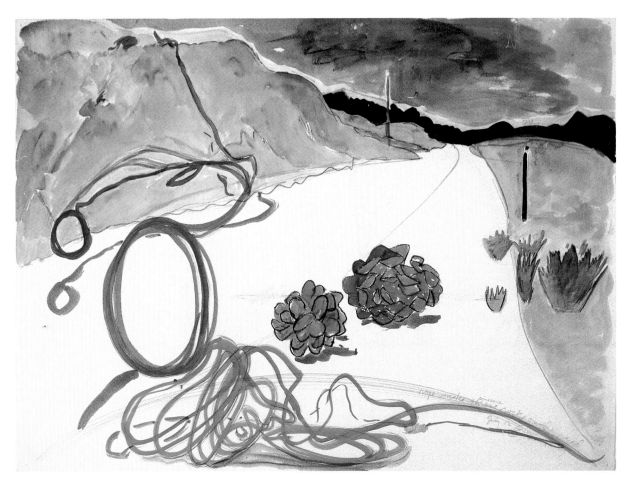

Rope Snakes, Road to Zuni, 1979

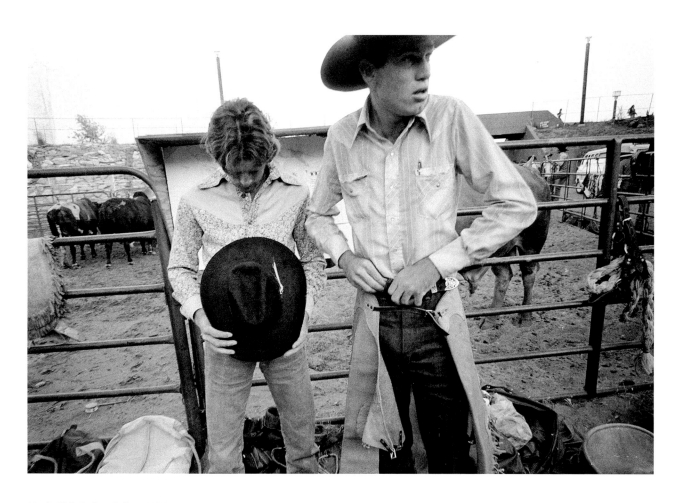

Lion's Club Rodeo, Gallup, 1979

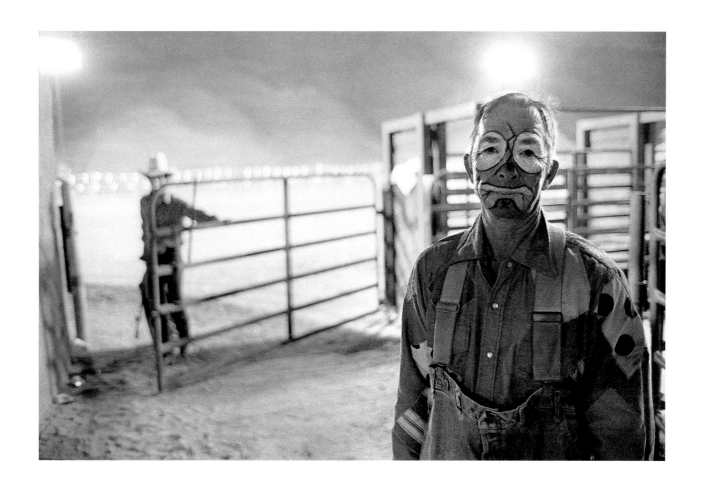

Lion's Club Rodeo, Gallup, 1979

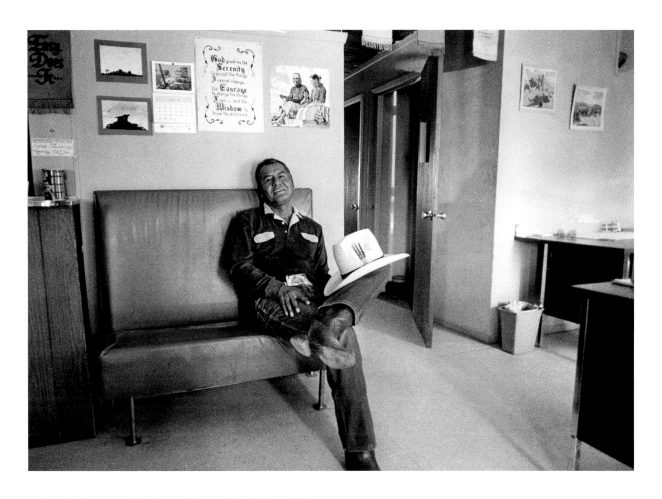

Jackson Arthur, Counseling Center, Thoreau, New Mexico, 1980

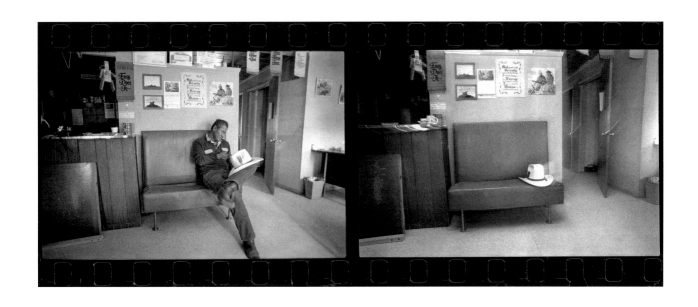

Jackson Arthur, Counseling Center, Thoreau, New Mexico, 1980

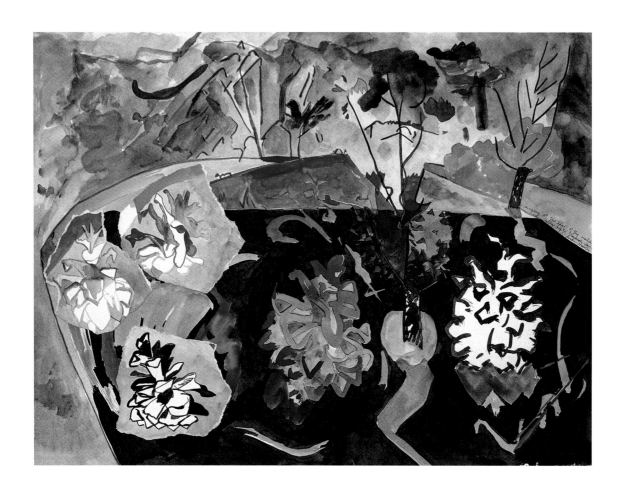

Pinecones from the Chuska Mountains, 1981

104

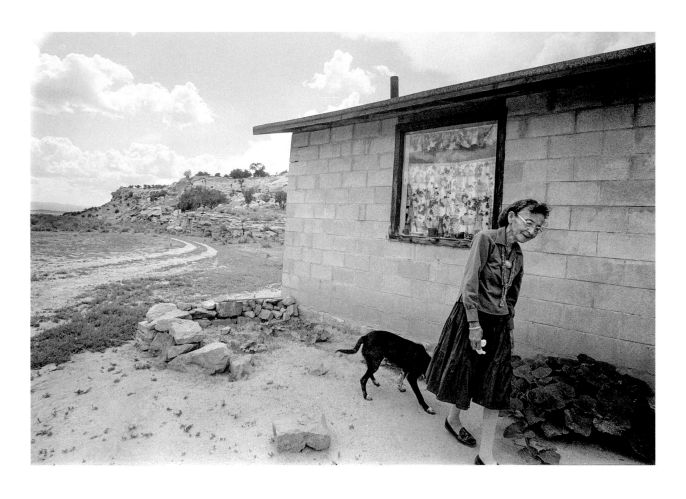

Mrs. Martinez, Near Thoreau, New Mexico, Navajo Nation, 1981

When I drove across the country in 1964, there was an interruption in the interstate. From west to east, there was no alternative but to drive through Gallup on US 66. It started at the Truckstops of America, and traversed nine miles of motels, neon and commerce. Driving through town, before emerging back onto the familiar freeway, I had the impression that I was skirting the sharp edge of the universe. Closely parallel to the north side of the road, there were railroad tracks and seemingly vacant desert; to the south, on the passenger side of the car, there was a milling procession of street people, pawn shops, and bars. The road seemed to me like a knife slicing its way through the disparate parts of an uneasy whole. I was struck by the tension. Its memory stayed with me. I wondered who lived there, and what it was like for them.

RA, journal entry, July 18, 1979

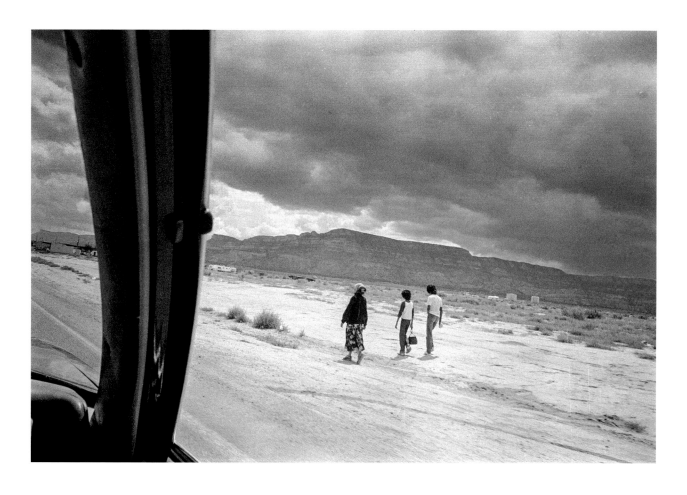

Near Kayenta, Navajo Nation, 1979

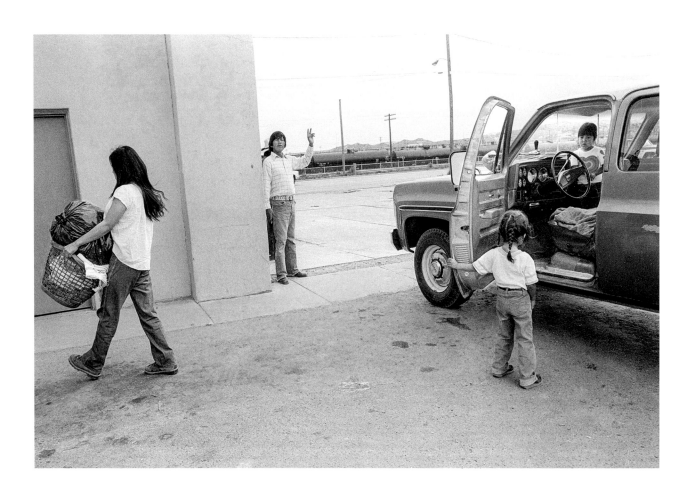

Laundromat, Gallup, 1981

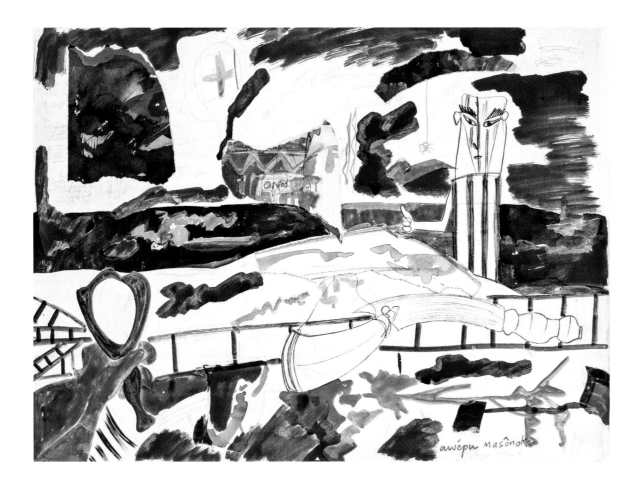

Hitchhiker and Powder Horn, 1980

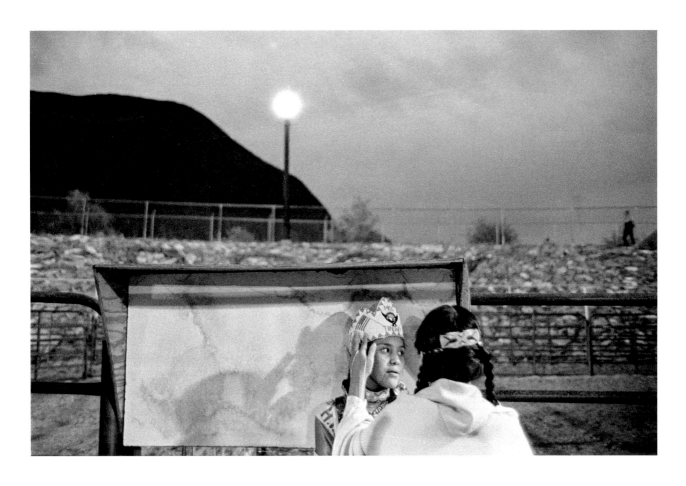

Inter-Tribal Ceremonial, Gallup, 1979

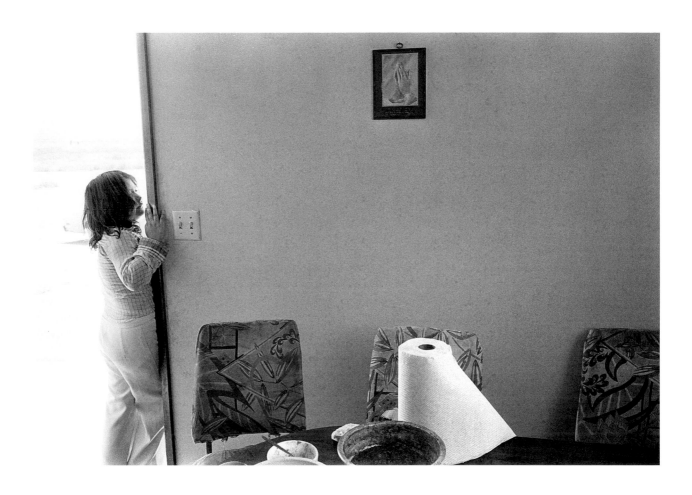

Tribal Housing, Crownpoint, New Mexico, Navajo Nation, 1980

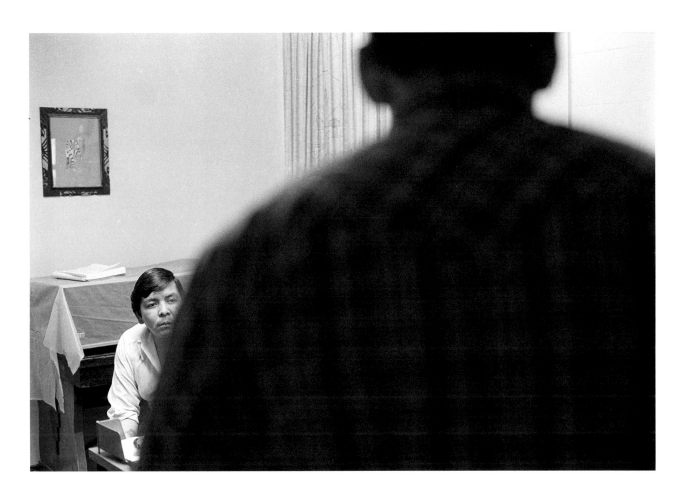

Counseling at the Gallup Indian Center, 1980

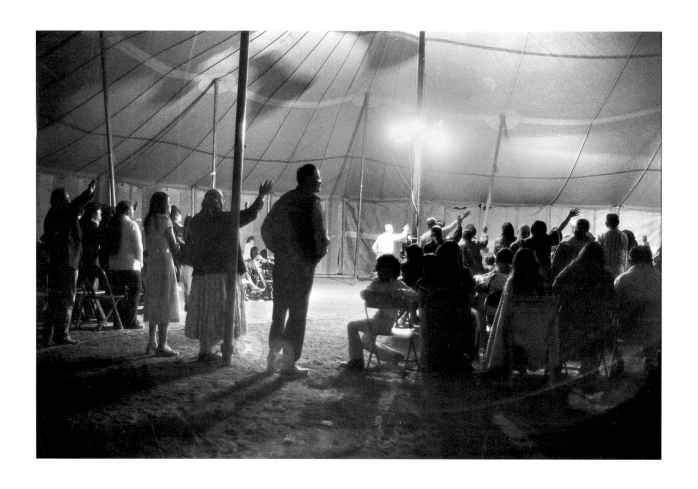

Revival Meeting, Gallup, 1980

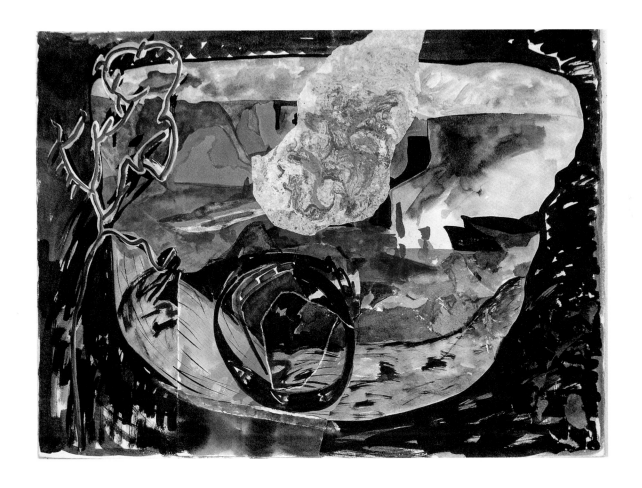

Belt Snake, Cave, Canyon de Chelly, 1980

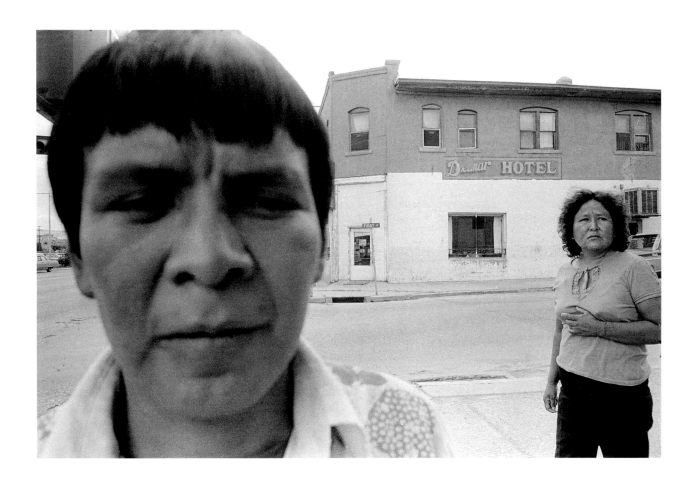

Emerson Shorty, Gallup, 1979

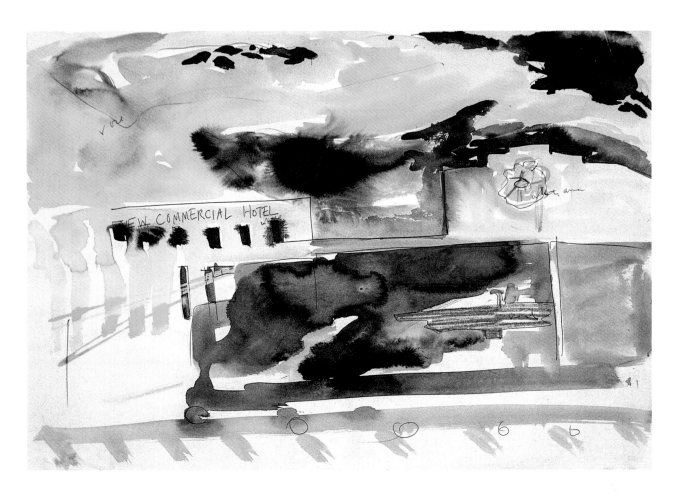

Train Next to Route 66, 1979

121

I saw Roscoe today at the Indian Center. He told me his brother had just died. He had cirrhosis of the liver and his kidneys had failed.

"Too much whiskey," Roscoe said, with the same unbearably sweet smile that always accompanied his horror stories.

A few feet away from us, an old man was talking to a small crowd, speaking quickly in Navajo, his hands moving slowly upward as he talked, making emphatic spirals in the air.

"He's talking about the Emergence," Roscoe told me, noting my curiosity about the nearby conversation. "He's talking about when the First People were made, when they came through a hole in the ground and entered into this world."

RA, journal entry, August 12, 1980

Roger Pablo called from Gallup today to tell me that Roscoe was dead. His liver gave out, and he died in his sleep. He was 34 years old.

RA, journal entry, July 18, 1981

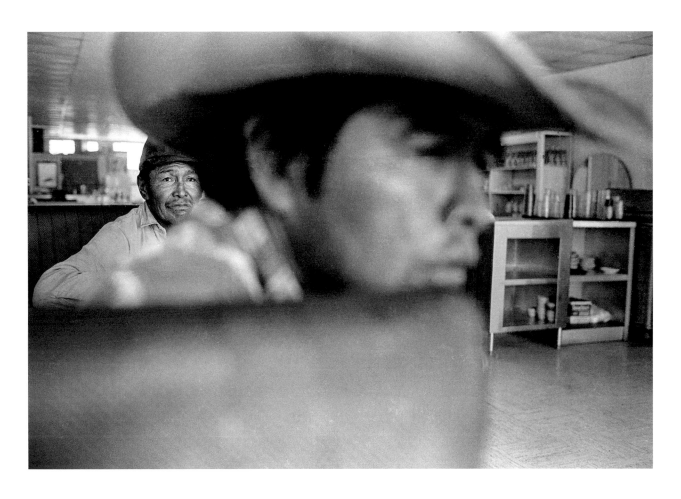

Roscoe and Bennie, New Inn Café, Gallup, 1979

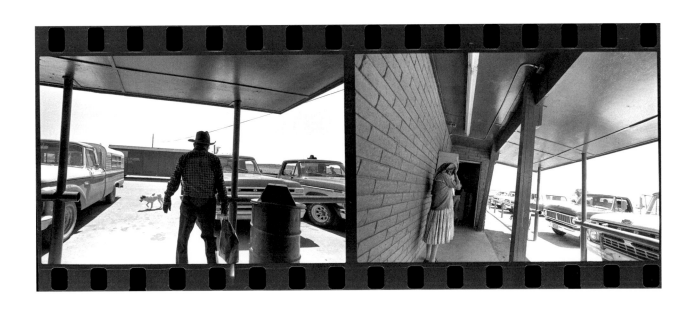

Sanders, Arizona, 1979

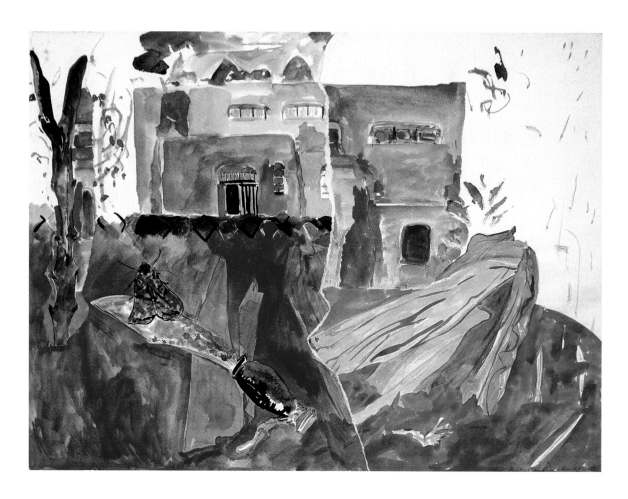

Tamale Angel, 1979

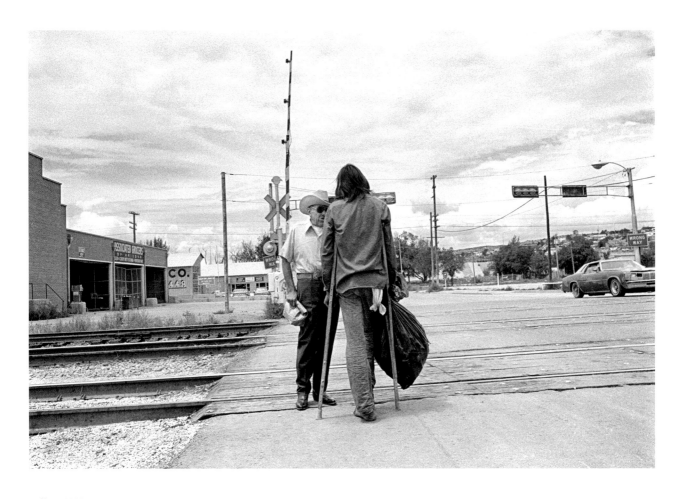

Gallup, 1981

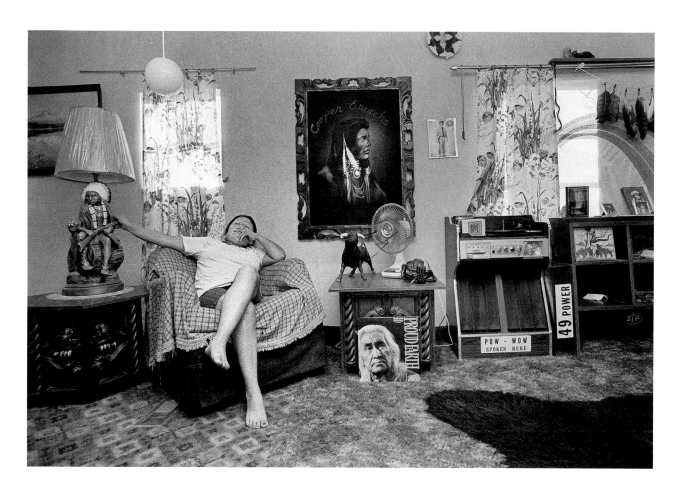

Marie Eriacho, Navajo Nation, 1980

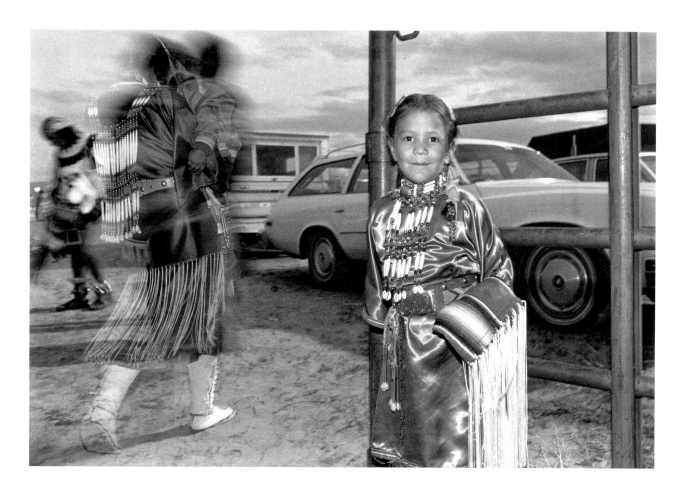

Inter-Tribal Ceremonial, Gallup, 1979

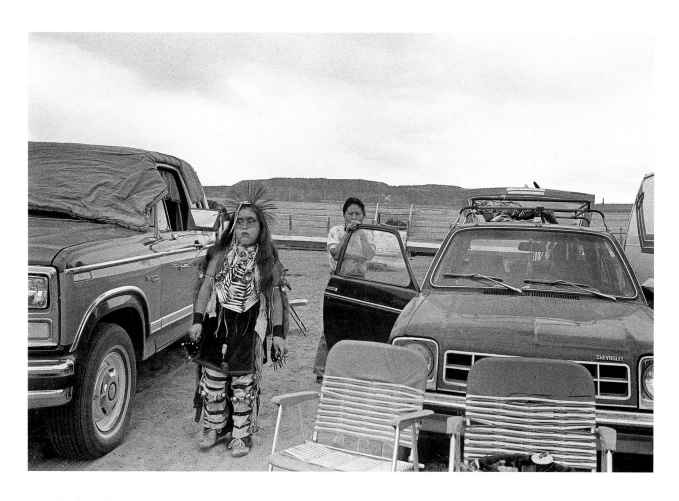

Marie Eriacho and Her Son, Pow-Wow, Navajo Nation, Lukachukai, Arizona, 1980

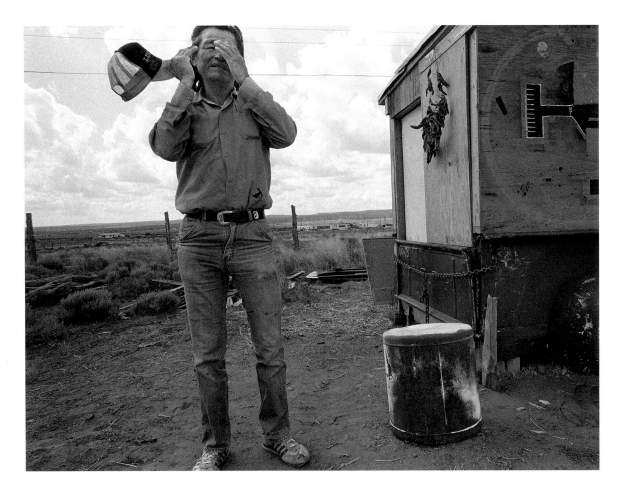

Bronco Martinez, Thoreau, New Mexico, 1981

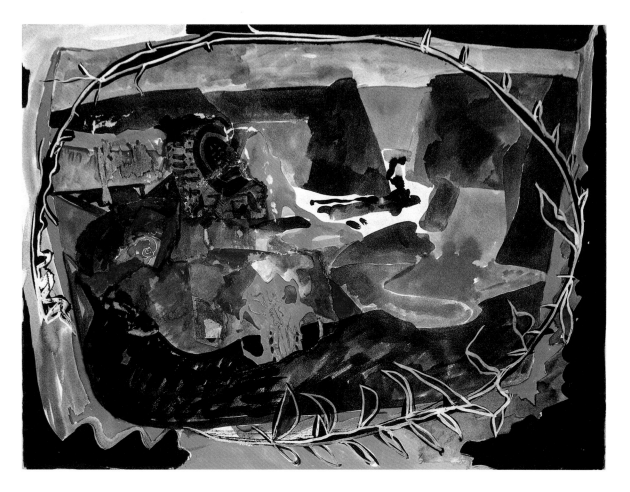

Cave, Canyon de Chelly, 1980

Darkness comes. Sounds creep out: whippoorwill, tree frogs, roar of alligator back in the pond . . . the scream of a cat in the swamp. Sounds like these weave in and out . . . pulling in hearsay tales . . .

Sometimes as you sat there, crazy Miss Sue would walk down the road giggling to herself. You'd say "Howdy Miss Sue," and she would hurry past breathlessly as if to keep a late appointment or maybe she would stop, turn, look at you gently as if you were a childhood dream and then float away in the dusk. And you would watch her, bemused, not certain whether it was Miss Sue or your own strange notions walking down the road with you.

From Lillian Smith, *Killers of the Dream*, 1963

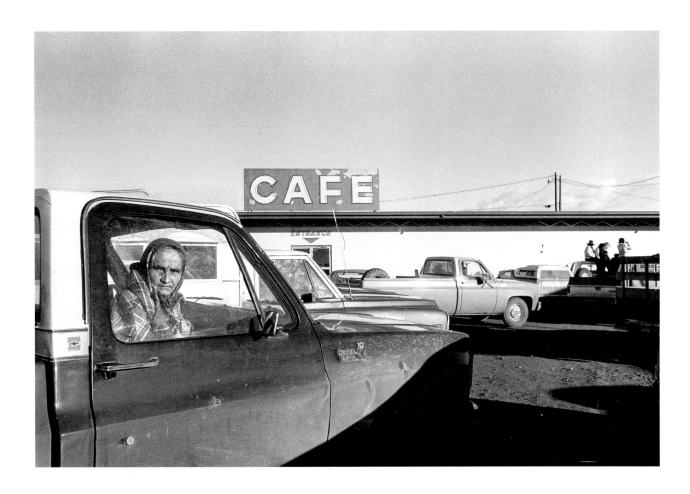

Ya-ta-hey Community, on the Road to Window Rock, 1979

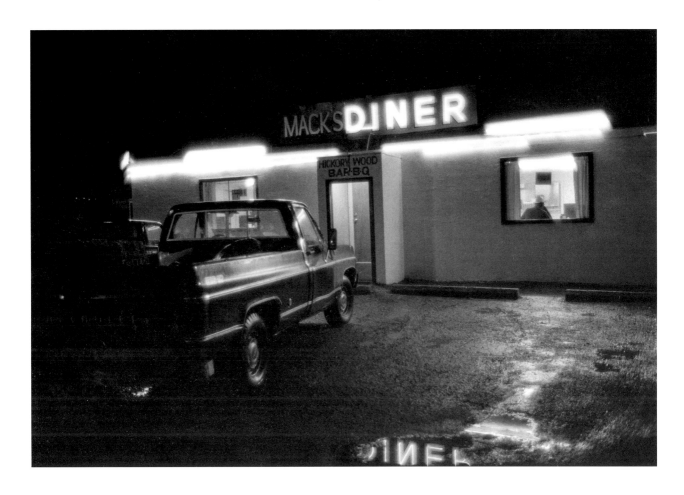

Gallup, 1979

We often went to nearby Cibolla National Forest, to Quaking Aspen campground, just to take a break from Gallup. We went in the middle of the week, when it was quiet. Set up a tent, built a fire.

Today, Roswell started to photograph the fire, the chairs, the tent. It was too much for me. I had had it with his constant picture-taking. I wanted to take part in the process but I also wanted him to stop, to just relax and lie there, listen to the trees. We had a furious fight among the aspens. I ran past several large anthills, to an open dirt bank. I found a knife made in Solingen, Germany. It looked showy and sadistic. Black and yellow-winged grasshoppers were making a racket, flying around wildly in the air, in great buzzing leaps. I threw the knife back into the bushes where I'd found it.

After that, I no longer used my own knife—homely and functional as it was—as an object in my paintings. I looked at other details downtown, trying to get at the crazy sadness and delicate energy I felt was there.

The steps of an old hotel I festooned with a flag. The horsehair belt dad gave me I painted rolling up the street. Moths for the fragile souls. I felt myself more and more to be the stranger, witness to a situation, a junction point that floated in front of me, open but tantalizingly opaque. It was not a movie set, but sometimes it only seemed penetrable as something like that, as a stage where great American myths played themselves out.

SH, journal entry, June 11, 1980

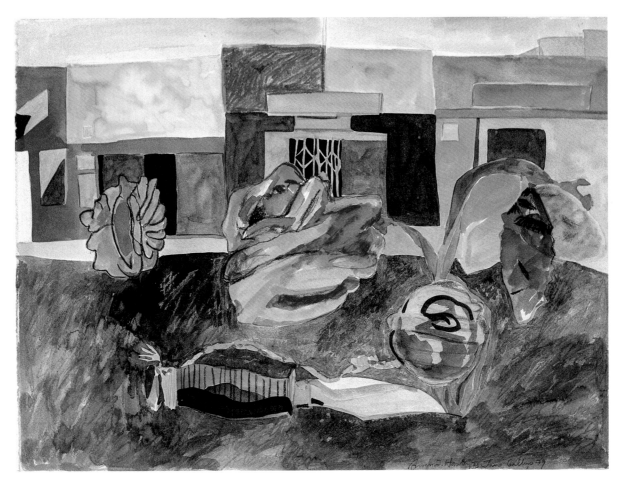

Rose Rocks, Knife, and Shard, 1979

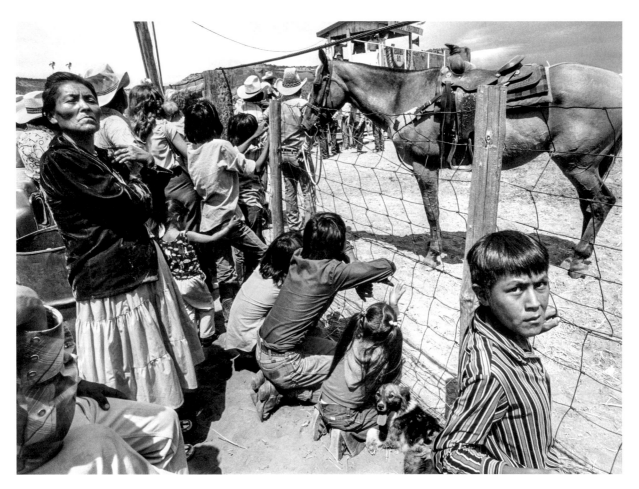

Paddy Martinez Memorial Rodeo, Thoreau, New Mexico, 1981

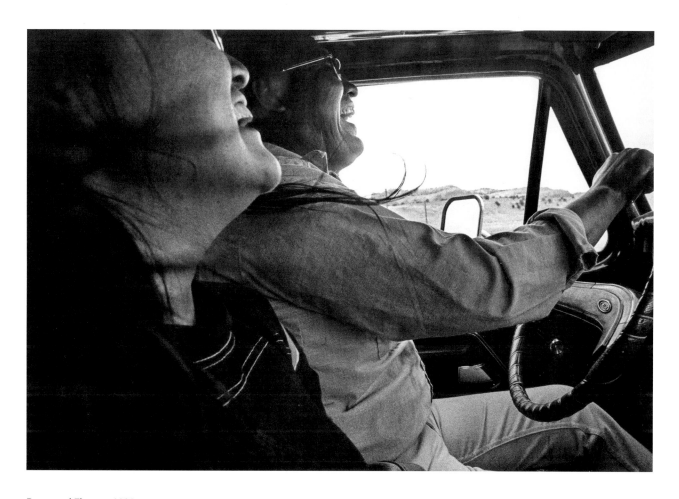

Roger and Eleanor, 1981

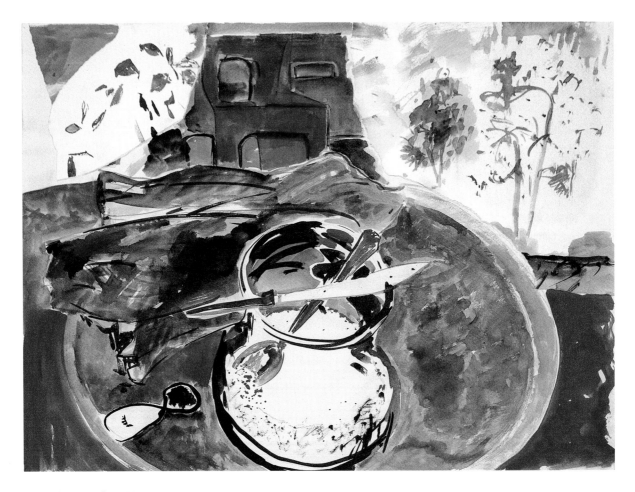

Salt and Ivory Knife, 1979

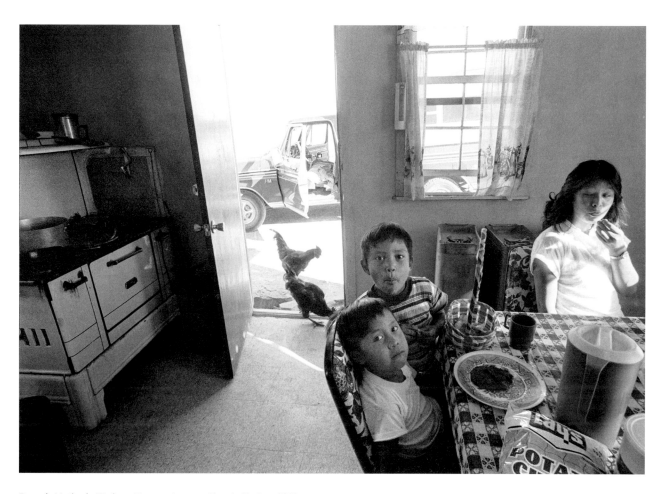

Roger's Mother's Kitchen, Eastern Agency, Navajo Nation, 1980

Johnny won four prizes for his paintings at the Inter-Tribal Ceremonial. He's been in town celebrating. He's been drunk for most of the past three weeks. He's tired, and he wants to collect his prize money so he can go home to the reservation. The traders who handle his work say they don't know where the checks are. Joe Tanner, a Mormon art dealer, gave him a lecture about his drinking. Finally, Johnny borrows $25, enough to get home on, from Johnny Porter, a friendly trader from Texas.

Susan and I drive Johnny and his wife Wanda to Indian Wells, where Johnny's mother has a sheep camp. We were invited to spend the night. Johnny is soon on his fourth quart of Garden Deluxe and is getting really drunk. He talks about his experience in Vietnam, being point man on night patrol in the jungle. He starts hallucinating about snipers, eating dog and monkey steaks, huts on fire, rivers colored with blood.

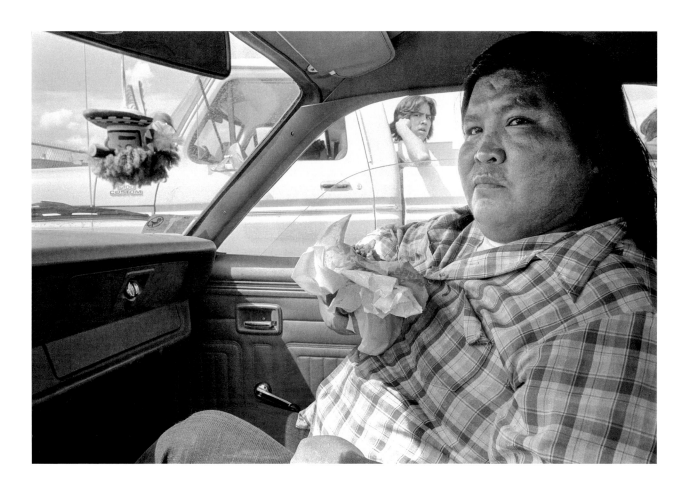

Johnny Secatero, Burger King, Gallup, 1980

It's night. This is my first experience of sitting up all night with a serious Vietnam veteran. I'm holding Johnny's hand in the darkness. He senses my gathering anxiety and starts squeezing my hand hard. My snake ring starts biting into my middle and little fingers. His whole body seems to condense into an enormous rage, his fat squeezing hand that he uses to paint Shalako dancers with such exquisite detail, all finesse gone. I feel trapped, can't remember where I put my glasses, can't see anything in this gelatinous darkness. I can only absorb his rage and try to let go. Finally Johnny loosens his grip. "That's better," he says. "Sit up and drink with me a while, little brother, I feel troubled." A little while later he is talking in his sleep, mumbling about something far from Vietnam, something about New Orleans and the women on Bourbon Street.

The next day Johnny is shy and hung over. He and Wanda load our car with government food that they don't want. Johnny's mother gives Hollysue a juniper berry necklace and some pieces of petrified wood. I take pictures of the roosters and goats. It's time to go. Johnny shakes hands, smiles. I want to say something about last night, but don't. Or about the night before last, in Gallup, in his room at the Harvey Hotel, Wanda already asleep on the broken-backed bed, Johnny in the middle of the room presiding over three bags of groceries, saying, as he put his arms around me, "Tell your people that you have been hugged by a Navajo wino in Gallup, New Mexico. Tell your people that, will you?"

RA journal entry, August 12, 1980

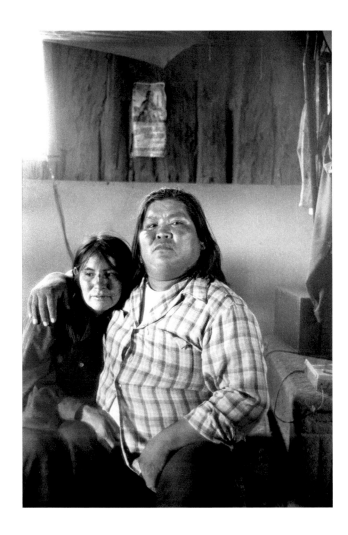

Johnny and Wanda in His Grandmother's Hogan,
Lukachukai, Arizona, 1980

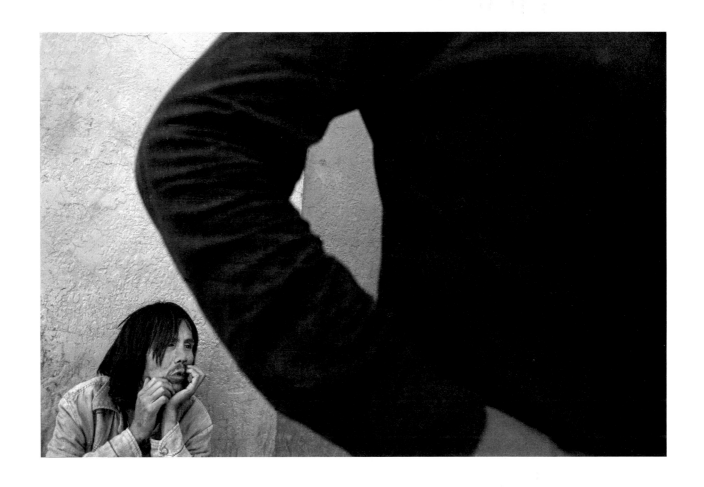

Irving Begay, Gallup, 1979

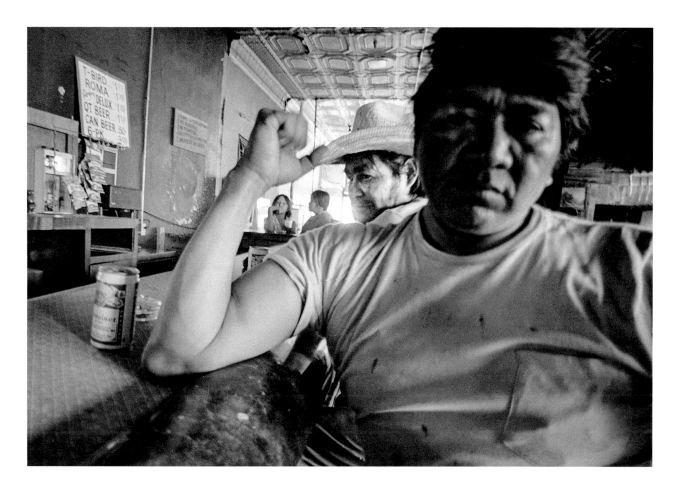

Indian Head Bar, Holbrook, Arizona, 1980

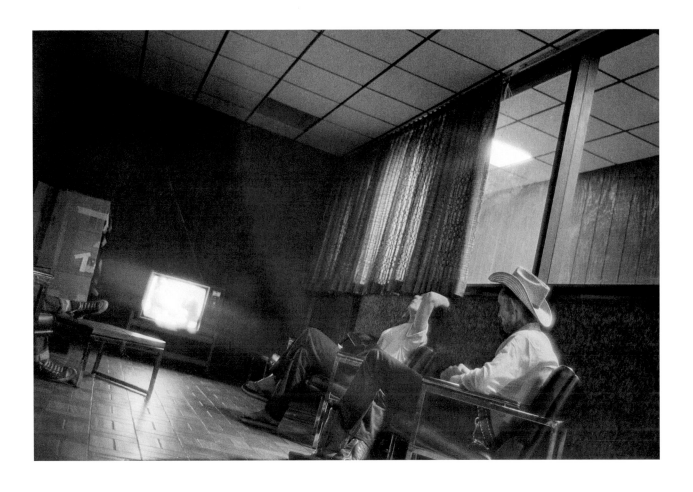

Truckstops of America, Gallup, 1979

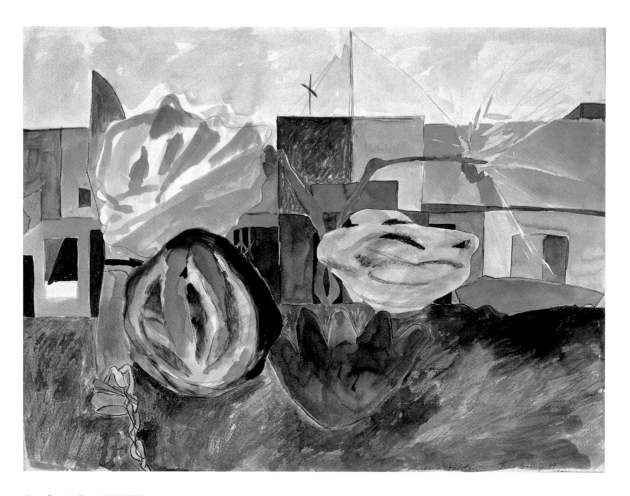

Storefronts, Route 66, 1979

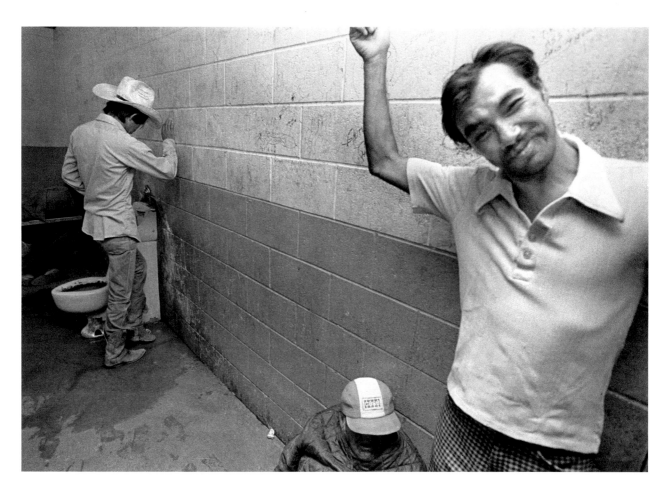

Gallup City Jail, 1979

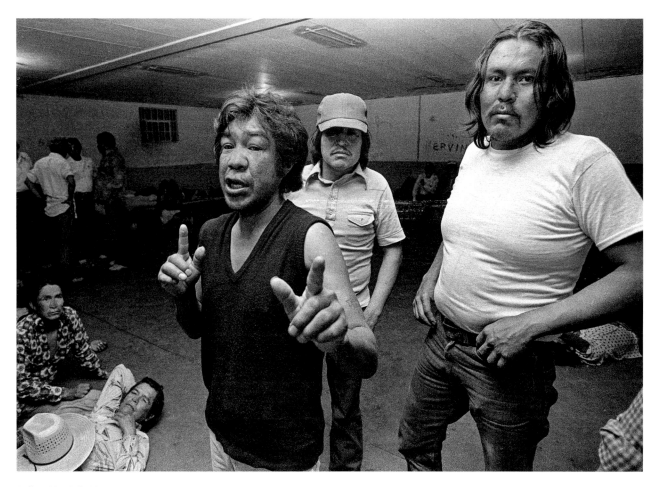

Gallup City Jail, 1979

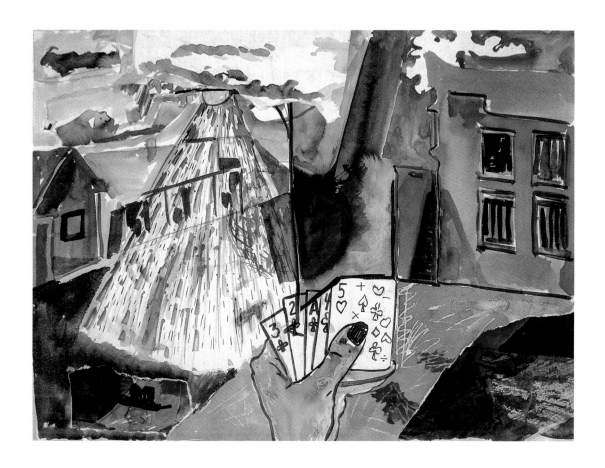

High Stakes, Gallup, 1980

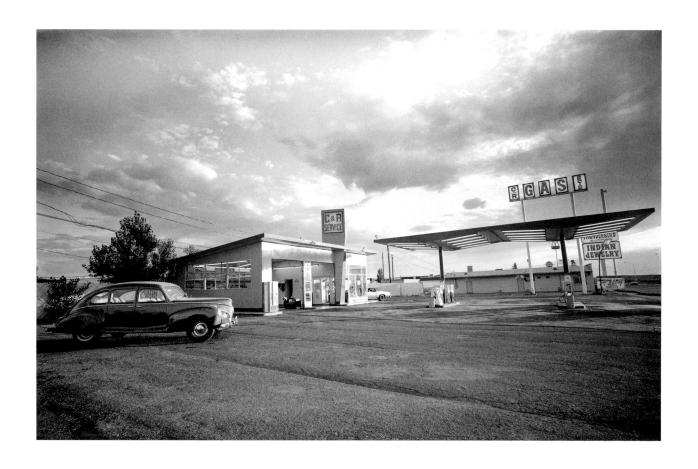

Gallup, 1979

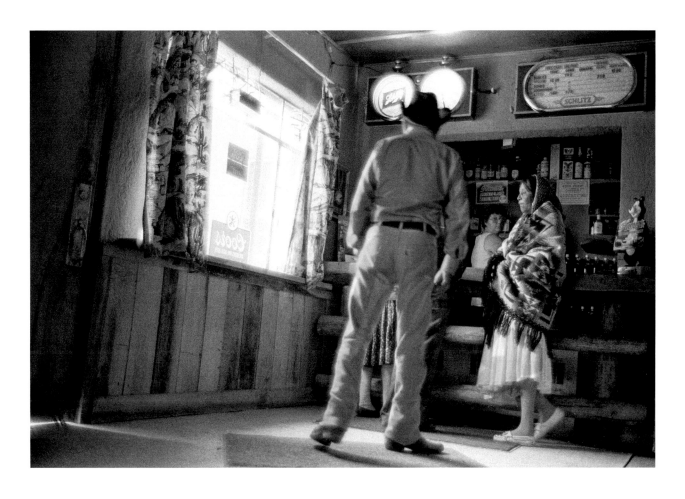

Bar, Near Crownpoint, New Mexico, 1979

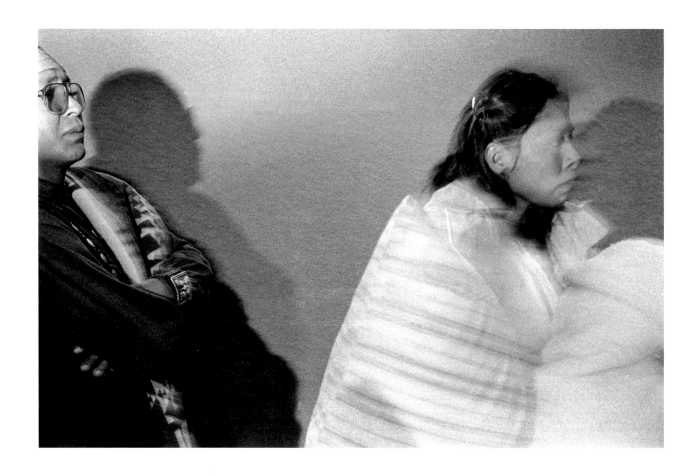

Inter-Tribal Ceremonial, Gallup, 1979

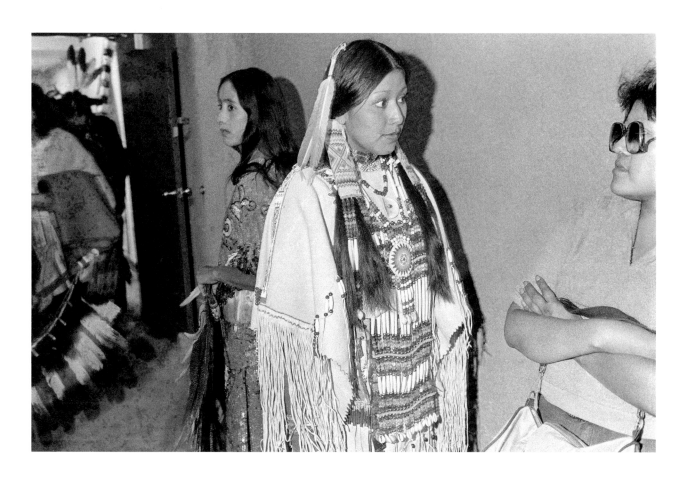

Inter-Tribal Ceremonial, Gallup, 1979

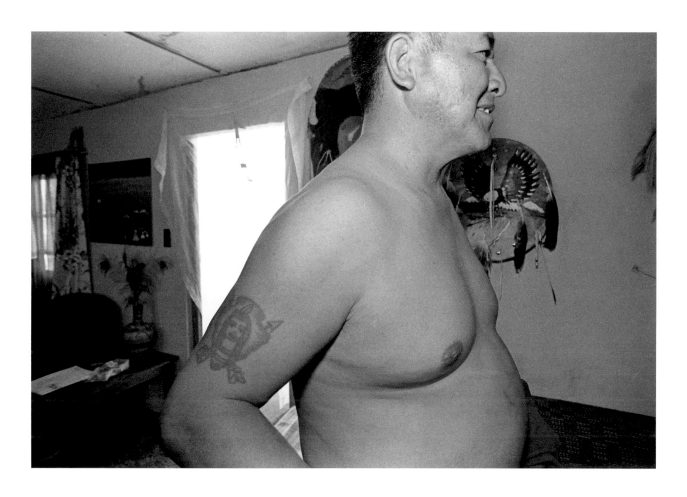

Frank Eriacho, Navajo Nation, 1980

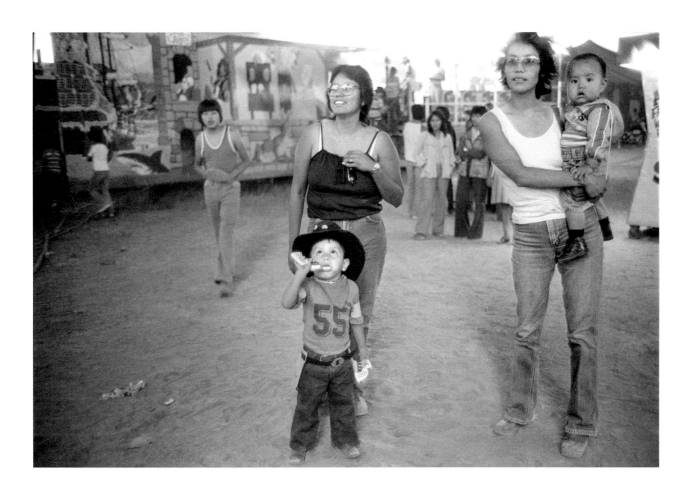

Carnival, Gallup, 1979

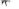

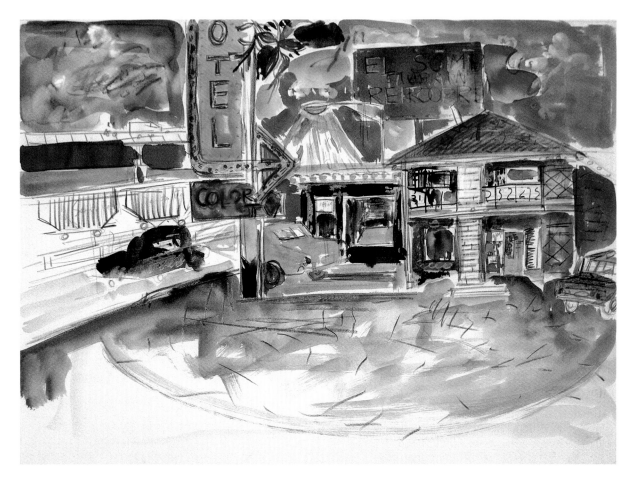

Golden Desert Motel, 1979

Beckett was our beloved dog, and travelled everywhere with us. Navajos traditionally have absolutely no appreciation whatsoever for pets. They're not reviled, they're just not on the radar. I don't think I ever once saw a single cat anywhere on the reservation, and don't remember seeing any felines in Gallup either. Dogs were tolerated because they were thought to have a sensitivity to skin-walkers, who were a special kind of lycanthropic witch, and were imagined to be grave-robbers. Traditional Navajos were especially phobic about everything associated with death, so dogs were useful guardians in respect to the possibility of witch trouble brewing in the neighborhood.

RA, email to Tom Weaver, January 9, 2022

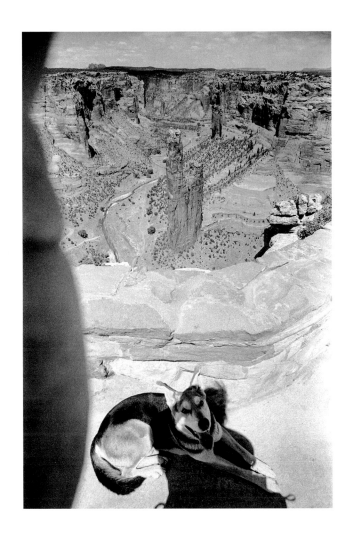

Beckett, Canyon de Chelly, Navajo Nation,
Chinle, Arizona, 1980

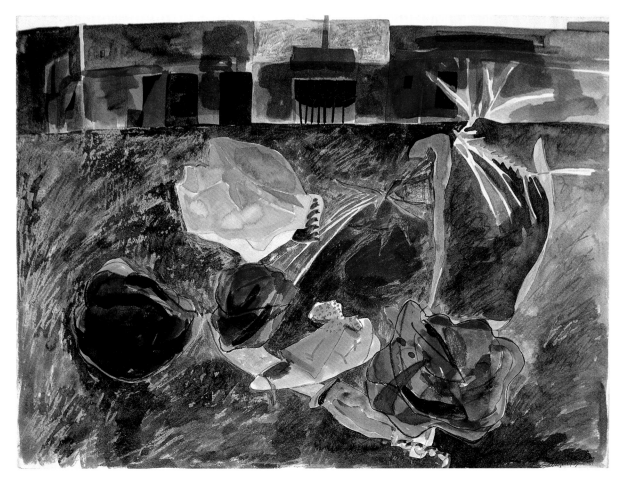

Storefronts with Rose, 1979

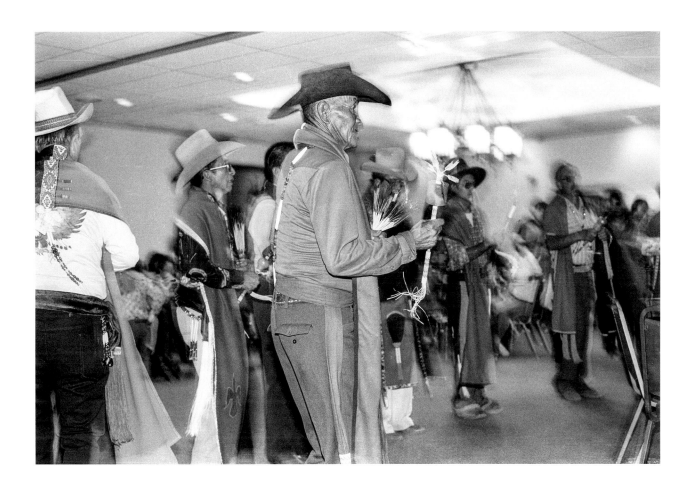

Pow-Wow, Best Western Motel, Gallup, 1979

It's 6:00 in the morning. Driving out of town with Roger, heading for coffee at the truck stop, before a long drive onto the reservation to a gathering of Roger's Water Clan. We pass the Club Mexico, where there are already a couple of winos hanging outside, waiting for the bar to open. Roger has been sober for six years now. As I look out the window of his pickup, across his broad and friendly face, I feel like I'm catching a glimpse of his past life, much of the pain now dissipated. The bent figures on the sidewalk outside are like mirages in the bright winter light.

RA, journal entry, January 8, 1980

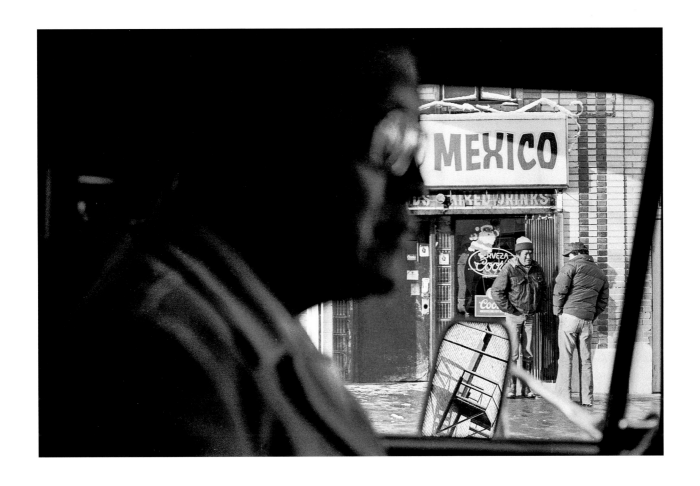

Roger Pablo, Gallup, 1980

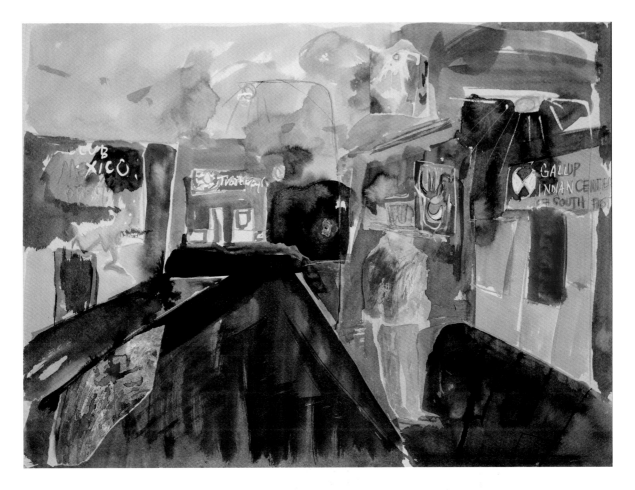

Club Mexico, 1980

Downtown, early. People are gathering in the park next to the Chamber of Commerce. Some have just finished the long walk from jail, where they have spent the night in the drunk tank. There are families, old women in traditional dress, knots of silent men in trucker's caps, waiting for the bars to open.

I'm talking to Felix. He's telling me about the wolf-people. Navajos call them the night walkers. Felix says they run on their elbows and have crosses for eyes. "They're witches," he says, "you can't kill them unless you dust your bullets with ashes. Even then, they probably wouldn't die, because they're supernatural. If they throw corpse powder at you, you're dead."

Felix says he is a medicine man. Not from around here. His people are from Oklahoma. He knows about the Trail of Tears. Cherokee rose rocks. "After they hit the ground," he says, "those tears turned into stones the size of golf balls. You can buy replicas in the tourist stores near where I come from."

"I can change the shape of things, the way they appear to your eye. The old men taught me how to do that. I can change this whole street into an explosion of color. Many things would disappear. Do you want to see that?"

RA, journal entry, July 10, 1979

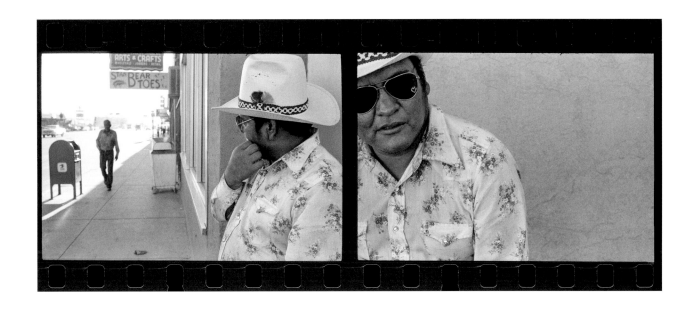

Felix, Gallup, 1979

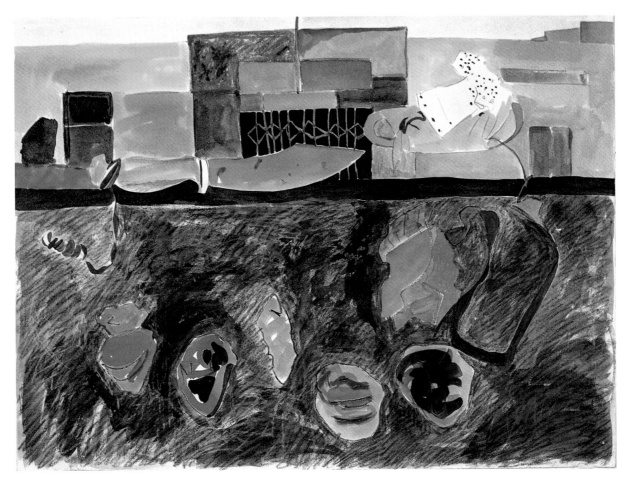

Storefronts with Knife and Beaded Dress, 1979

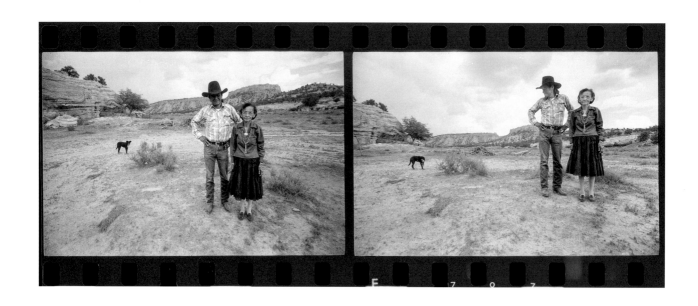

Bronco Martinez and Mrs. Martinez, Eastern Agency, Navajo Nation, 1981

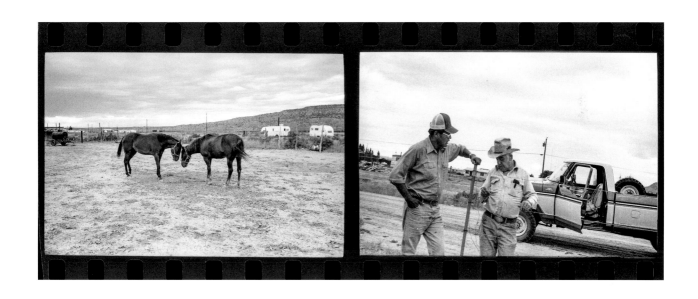

Roger Pablo and Friend, with Their Horses, Gallup, 1980

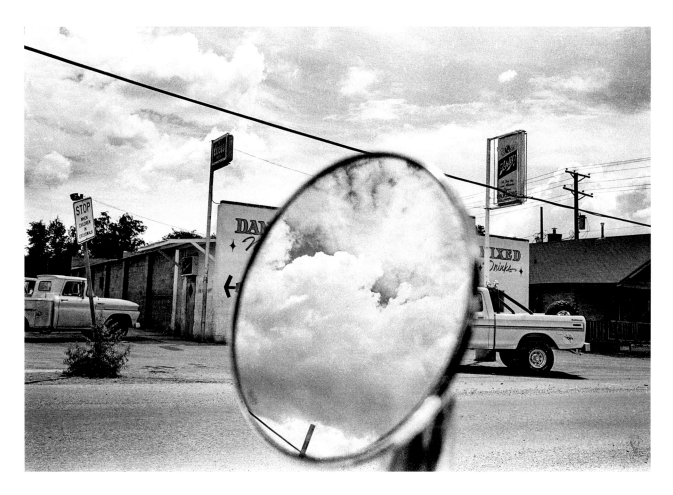

Outside Eddie's Club, Gallup, 1979

A crow flies back and forth in wide circles, calling. The air is cool, the sun is setting. We were sitting in a cave halfway down the path to White House Ruin, looking out and down on trees. Canyon de Chelly was the perfect foil to Gallup. When the emotional pressure got oppressive, either from our own effort to find the source of tension or from other people trying to get a handle on us, trying to figure out why we were there, this quiet, large, and complex space became a special destination, a necessary source of peace.

We would take off spontaneously, sometimes forgetting to pack our tent poles, so there would be no overnight camping, just a long day trip. More often, the tent made it into the car with the rest of our gear, and we would know, as we cruised by Beautiful Valley, that a quiet supper by a fire in the campground would soon be in the offing.

The shallow cave, full of "no-see-ums," was one of many in the canyon walls, but unlike most of the caves, access to it was easy. As I began to draw, I would feel my mind and my eyes taking on substances as I looked out onto this landscape, so full of sharp contrasts between electrifying color and intense shadow. On the floor of the canyon, tire tracks could be seen near the silver lines traced by the river bed.

On a previous trip, I drank delicious water from the canyon, offered at the entrance to Canyon del Muerto as part of a guided Jeep ride.

SH, journal entry, August 23, 1980

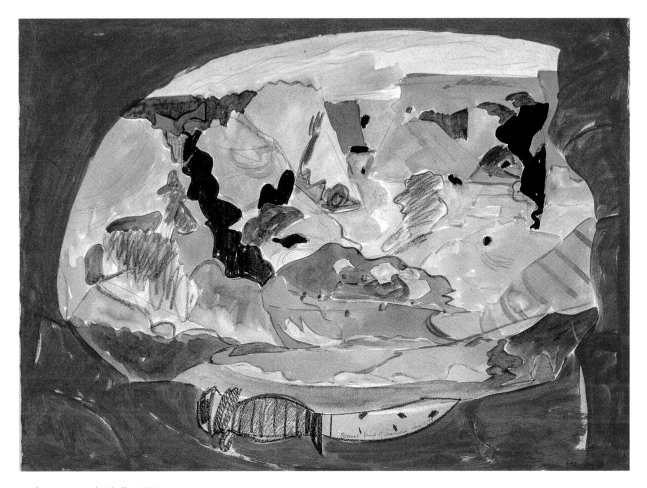

Knife at Canyon de Chelly, 1980

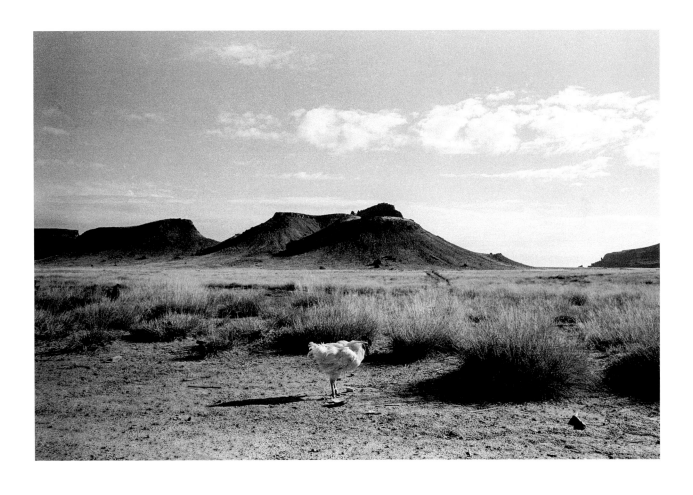

Navajo Nation, Near the Lukachukai Mountains, Arizona, 1980

AFTERWORD: GALLUP, NEW MEXICO, 1983 BY RAMONA EMERSON

There were nine hills between my grandma's house on the reservation and the town of Gallup. It was one of the ways that Grandma had taught me to count, and it was something that we shared right up until her last days. I had memorized every house, every cattle guard on the way to town. Town was the place where we had to go to get anything—groceries, shoes, doctor appointments—all of it 25 minutes down the road from our community.

My grandma turned our daily trip into town into the most fun a kid could have. Any trip always included a trip to Earl's or maybe a trip to Baskin Robbins if we "knew how to act." We bought groceries at the California Supermarket, where the registers were filled with colorful candy wrappers and magazines and where the cashier put their thumb into the giant Green Stamp wheel and rolled out stacks of green stamps for the G&H store on the corner. That store was always filled with shiny kitchen appliances and dishes that we wouldn't be able to use. Mostly, Grandma gave us her stamps and her stamp books so we could lick the stamps for her and put them back in her purse. Aside from buying us a couple of toys and candy, I don't remember Grandma ever buying anything of immense value. Mostly, we just looked through the windows.

Carnivals came in and out of the reservation all summer and when Grandma knew they were in town, she would tell us to look for things under the seat of her car. Once she had passed by the lights and dust of the rides, she always surrendered her quest and let us get up. I looked for her purse, her Kleenex, and her glasses all summer. It took years for me to figure out what she was doing.

Back then there was a drive-in in Gallup up where the police department is. There was a roller-skating rink and a Sirloin Stockade with one of those huge, fat plastic cows out front. Grandma joked that we should take that big cow to the hill behind her house, so no one would move close to her house. I wish we had. It would have worked.

It was the 1980s and the world was changing faster than any of us could keep up with. There was world famine and widespread greed out in the world beyond our borders. We connected to it through Grandma's old radio and the occasional television signal we could pipe. We still knew when things were happening. We did Hands Across America with Grandma and her old truck out in the middle of nowhere east of Gallup so that we could help bridge the areas where no people could continue the connection. We just closed our eyes and moved with it. That was my grandma's influence.

Grandma took us to see scary movies at the El Morro and at the Aztec. The Rio West Mall had opened then too, a new concept to a dusty and empty part of west Gallup. My cousin cut hair in the salon inside and we spent many summers begging grandma for quarters outside of the arcade, waiting for her to get off work. It was a childhood much like any other kid living in a city or a small town anywhere. But we did not live in Gallup. Gallup was the place we had to come. It still is.

My own childhood memories are a reminder of how lucky I was as a young Navajo girl on the reservation. I had a family and a sturdy, big house to live in. My grandmother took great care of me and taught me so much. But as I got older, I began to see the things around me that were dark and dangerous—the memories of an uncle, who drank and became a menace in our driveway, the passing of young relatives and friends, the massive rivers of mud that would flood our roads and communities, digging ditches in my grandma's yard in the rain to keep the water from coming into the living room. But I was lucky. I had it all. I began to see how little everyone around me was given. Gallup was a big part of that.

I remember that Gallup was a place to fear once the sun went down. The dark streets downtown bled neon out of trading post windows. Men staggered in and out of open doors along Aztec, the orange light filled with smoke. American flags slapped at street corners all summer, just like the old foil trumpets and candy canes that came out every winter.

The train screamed every half hour. When we were kids, Grandma used to tell us that the drunk men would get us when we misbehaved. We believed her. I can still remember the silence in the car when we drove past the men at the bars. They had the same silence in their eyes. Grandma kept us from there as long as she could, until we grew wings and went to town on our own.

As a teenager, I learned the history of Gallup and about the incident in 1973 (the year I was born) that killed Larry Casuse. I had an "uncle" I called Uncle Bob—a Robert Nakaidinae—who grew up with my mom in Church Rock Village just outside of Gallup. He was there when the Gallup police killed Larry Casuse and he was part of the movement to change the way Navajos existed in border towns. They kidnapped the mayor to expose his hypocrisy—the monetizing of Navajo suffering. None of it worked. Larry was murdered by the police. But Uncle Bob never told me that story or about their fight. He took me to the horse races in Albuquerque. And here 50 years later, little has changed in Gallup.

The term border town is a reminder of the violence that continues. Over the last five years, I have researched and studied the history of violence in the border towns around New Mexico and Arizona. In Gallup, the racism is still palpable. The Covid-19 pandemic exposed what many of us have known for years—that Gallup is dependent on the Navajo dollar. With curfews in effect, Navajos were unable to make their way into Gallup stores. The economy suffered. Everyone complained about the "infected" Navajos. It wasn't shocking. It was what I expected from this town. The town that began as a necessity for the building of the railroad continues to represent the continued colonization of Native lands from the 1880s through today. My research has only confirmed that fact. Now, surrounding border towns like Farmington and Albuquerque are being exposed for the same kind of racism—the police violence, the victimization of our relatives living on the streets, the continued support of extractive industries and high interest loans, and the lack of jobs and opportunities.

When I first saw the works of Roswell and Susan, I couldn't help but think of those men I saw emerging from the portals of bars and street corners. The men who scared us into our best behavior had the same fear and silence in their eyes. Reading about their experiences on the streets of Gallup made me more aware of the people who continue to live on

the streets in town, far away from their families and their lands. It reminded me of Gary, a young homeless Navajo man that I met over ten years ago on the streets of Gallup. "They don't want to see me," he would say. He died on the streets of Gallup too, hit by a car. The police officer who hit him didn't see him. He knew it.

These images remind me that the men and women on the streets are our relatives, no matter how deeply they have fallen into despair. For many of them, all they needed was to be seen. Johnny Secatero needed to be seen. Roswell and Susan saw him. These images made him feel seen. It is hard to see the images of these men, who remind us of our uncles, our fathers, our brothers, their wings dingy and torn. They were wounded by the world. But there is hope still. I saw it in the obituary of Johnny Secatero, who turned his life around and lifted his community with his knowledge and sacrifice, after his difficult life on Roswell and Susan's pages.

Tonight, they are still wounded, tethered to the land by the heaviness of the iron in the passing trains. They are looking for hope. They are still there on the streets waiting for us to see them.

ACKNOWLEDGMENTS

We are indebted to our fathers, Alfred Minor Hawley and Roswell Parker Angier, Jr., for catalyzing our interest in Native American culture; and to our friends—to Bob Ellis for his timely help in getting us started on our travels, to David Joselit for invaluable suggestions, to Pauline Sice of the Gallup Indian Center, and to Roger Pablo, for being our guides to the territory. Thanks also to Ramona Emerson for her beautiful afterword, to Margarita Encomienda for her graphic design and Matthew Abbate for his text edits, and to our editor, Thomas Weaver, who has been wonderfully supportive and helpful.

LIST OF IMAGES

The MIT Press would like to thank the anonymous peer reviewers who provided comments on drafts of this book. The generous work of academic experts is essential for establishing the authority and quality of our publications. We acknowledge with gratitude the contributions of these otherwise uncredited readers.

This book was set in PF DIN Pro by The MIT Press. Printed and bound in Italy.

Library of Congress Cataloging-in-Publication Data

Names: Angier, Roswell, photographer. | Hawley, Susan (Artist) | Emerson, Ramona, 1973- writer of afterword.
Title: Gallup / Roswell Angier and Susan Hawley ; afterword by Ramona Emerson.
Description: Cambridge, Massachusetts : The MIT Press, [2023]
Identifiers: LCCN 2022018597 | ISBN 9780262047715 (hardcover)
Subjects: LCSH: Gallup (N.M.)--Pictorial works. | Gallup (N.M.)--In art.
Classification: LCC F804.G25 A54 2023 | DDC 978.9/830222--dc23/eng/20220518
LC record available at https://lccn.loc.gov/2022018597

10 9 8 7 6 5 4 3 2 1